NORFOLK
VIRGINIA

Daddy,
I hope you
enjoy going down
memory lane. ☺
Love
Julma
2010

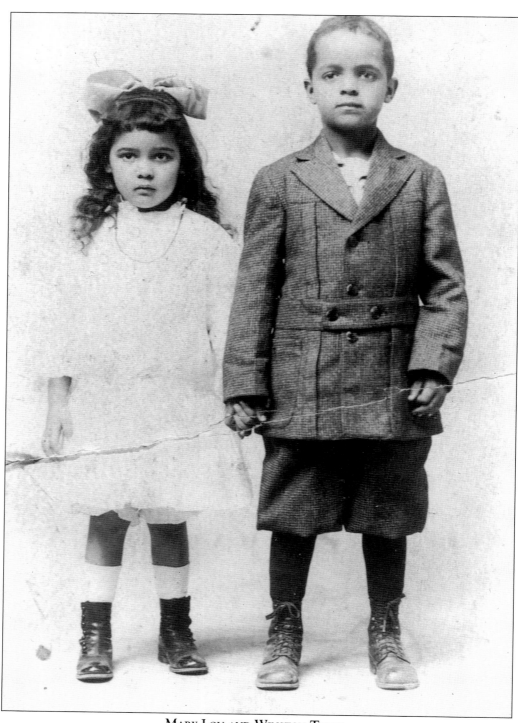

MARY LOU AND WINSTON TYLER.

NORFOLK
VIRGINIA

Ruth A. Rose

ARCADIA
PUBLISHING

Published by Arcadia Publishing
Charleston SC, Chicago IL, Portsmouth NH, San Francisco CA

Printed in the United States of America

Library of Congress Catalog Card Number: 00-101202

For all general information contact Arcadia Publishing at:
Telephone 843-853-2070
Fax 843-853-0044
E-Mail sales@arcadiapublishing.com
For customer service and orders:
Toll-Free 1-888-313-2665

Visit us on the Internet at www.arcadiapublishing.com

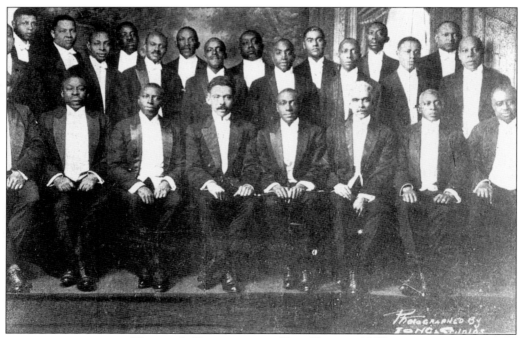

NORFOLK'S PHILHARMONIC GLEE CLUB IN 1927.

CONTENTS

ACKNOWLEDGMENTS

Each individual effort, no matter how small, is the product of the wisdom of many individuals. The effort to develop this book took the collective action of many people—some who provided inspiration; others who provided information; many who provided photographs; and still others who provided technical assistance, without which this project would never have come into being.

In the early stages, when the idea for this book was a blur, it was R.D. McCloud who provided the assistance and research necessary for establishing the foundation upon which this project would rest. And in the those foundation moments, G. Abbott and W.D. Smith's almost encyclopedic knowledge of the community where we all grew up helped shape the focus and provided the perspective.

As it became clear that this African-American images book on Norfolk would require endless hours of interviewing, searching for long forgotten photo images, and reassuring hesitant holders of these memories, it was M.L. Henderson, E. Brooks, E. Harris, H. Lassiter, M. Jordon, C. Coppage, J. Goss, O. Goss, O. Brown, T. Jones, K. Bibbins, T. Harrison, D. Vaughn, F. Craddock, L. Hite, R. Smith, Y. Baccus, J. Crusie, and E. Brown, who formed the cheering squadron, provided the necessary support, and helped make the contacts necessary for getting whatever was asked and needed with unwavering enthusiasm.

Although they would probably regard their helpfulness as "all in a day's work," I believe that this project would not have the scope that I felt it required without the following individuals. So an overwhelming thank you goes to Judge G. Jones-Jackson, P. Brooks, J.T. Brown, M. James, R. Clark, C. Hornik, K. Woodruff, city historian P. Hale, librarian R. Kinney, archivist A. Montgomery, and historian T. Bogger, Ph.D. At Atlantis Photo Processing, it was D. Wilson's interest in this project that assured that each reproduction would be of the finest quality.

Certainly without the cooperation of all those who allowed their memories to be reproduced here, this little volume would not have been possible at all. I am very grateful for the participation of the Banks, Bass, Bibbins, Bunch, Coppage, Dabney, Edmonds, Harris, Henderson, Jordan McWilliams, Omohundro, Smith, and White families, whose photographs appear in this book. Along with family images, many other images were reproduced from the photography collections—Carroll, Mann, Borges, Walker—of the Sargent Memorial Room at the Kirn Memorial Library, the archive collection at Norfolk State University, and the photo collection of Norfolk Community Hospital.

I do not wish to fail to acknowledge those who could not provide photo images. Often it was a case of a willing spirit and an open heart in spite of bureaucratic structures that required more time for approval than this project would allow, or in other cases, it was just not possible for personal reasons; nevertheless, I regard the time afforded to me as valuable.

No project I attempt could ever be completed without the involvement of L. Patterson, P. Duncan, H. Evans, D.J. Hodges, W. Francisco, and T. Jones, whose collegial support is always fundamental. Certainly the support and encouragement of Miss Candace and Miss Fannie made embarking on this journey possible in the first place.

INTRODUCTION

The story of the African-American community in Norfolk, Virginia, is a story of triumph over adversity—a delicate balance between opposition to the restrictive forces of enslavement, segregation, and discrimination and the achievement of the simplest goals that the nation was founded upon.

Norfolk's story is the story of the ordinary citizen, ordinary in the sense of being an American story replicated in varying degrees over and over since the beginning of the nation. What gives the African-American story its definition is not just the resiliency of its people, but the magnitude of the obstacles which had to be surmounted.

The African-American journey began somewhat differently than the journeys of others who came to this country. It began with the arrival at Jamestown in 1619 of 20 or so Africans. While they were not enslaved as such, they were indentured, which meant that their bondage had a prescribed length of service. Nevertheless, in spite of the circumstances of their beginning and the obstacles that were encountered, Africans were able to make their way toward the American Dream.

Norfolk, unlike many other towns in the upper south, was primarily a commercial port. It had and has the distinction of having one of the largest natural harbors on the eastern coast of the United States. Much of early Norfolk's economic growth was founded on maritime commerce, the exporting of tobacco, cotton, and various other products to other ports to then be shipped abroad. The institution of enslavement was as strong in Norfolk as it was in other areas of the south, but because of the nature of its commerce, Norfolk never quite developed the structure and culture of the plantation societies, which primarily depended upon crop cultivation for their economies.

By the late 1700s, Norfolk's population of enslaved Africans made up the majority of the labor force of drayman, ferry operators, and barbers. The early 1800s saw the manumission of a number of Africans who were able, through their industry, to pay their enslavers for their freedom. Many who could acquire additional resources were able to eventually purchase their own freedom and, frequently, the freedom of their loved ones. Buying freedom had the odd effect of making Africans unwitting participants in the enslaving process.

After the Civil War, the task of surviving freedom became the compelling challenge for those previously enslaved. For most, that meant finding a slot for themselves in the economy that would allow them to not only support their families, but also ensure their prosperity. Norfolk of the late 1800s and early 1900s offered that possibility; as a result, many came from the surrounding counties and from neighboring states. Norfolk then became the port of opportunity for African Americans who were seeking a better life and greater economic opportunity than had been afforded them in their county or state of origin.

This visual ethnography, in the loose sense, attempts to document the story of what I call the "ordinary" African American, who, much like the ordinary European American, began her/his journey with limited resources, utilized the resources at hand, and made a way in spite of many difficulties. It is the story of the great majority of Norfolk's African-American population who thrived by pride in self, hard work, industry, faith in God, love of community, and thirst for education.

This book contains eight chapters, each focusing on a particular aspect of that struggle. The period covered is roughly between 1800 and 1930. Initially the book was to contain just a collection of visual images that would portray life in Norfolk during the middle and late 19th century and the early 20th century. However, as I began to gather photo images that would bring to life the story of African Americans in Norfolk, a particular theme began to emerge that I had not anticipated. It was generally known that one of the prices of enslavement was illiteracy, but what was not known or realized was that it was a price also of Africaness. Unlike Charleston, South Carolina, and many other cities and states, no one of African descent was permitted to be officially taught to read and write in the state of Virginia after 1805. This injunction probably has many sources; however, most scholars have said that the injunction arose out of the fear of the enslaved being able to forge passes, papers, and other documents that would allow greater access to freedom.

Chapter One contains documents that belong primarily to the Nelson, Ridgeway, and Bass families. Most of them were passed down to Saintilla Ridgway through her parents. She carefully saved them probably for no other reason than that they were her family's legacy. In so doing, she preserved for us all some moments of history that we may have heard about but never hoped to see. Prominent in the first chapter are handwritten letters and copies of receipts that tell the story of one ordinary family of "free people of color" who made the best of what was available to them and, as the documents reveal, were able to establish a quality of life that many of that period would have liked to enjoy, both European and African.

Chapter Two highlights the Baptist movement in Norfolk. While there are many denominations here, the story of the original Baptist church in Norfolk is illustrative of the tensions between religion and law. In Chapter Three, the issue is not in obtaining freedom but, instead, surviving it. It is not uncommon to imagine what we would do if whatever harsh strictures binding us were removed. It is quite another to actually be able to survive in a new system. The challenge was how to make the best of a long-awaited dream. Chapter Four looks at some of the efforts made at establishing full literacy, which was thought of as one of the major keys to unlocking the doors of opportunity. In that sense, not much has changed, since education is still viewed by most immigrants and African Americans as the way to economic empowerment.

It becomes the task in Chapter Five to make sure that prosperity grows as opportunity begins to decline. Chapters Six and Seven cover public education and families. These two are tied together in many ways, even though here we have made an artificial separation. Chapter Eight highlights the efforts made toward quality health care and relaxing the mind and body through leisure.

The period from the turn of the century in 1900 through the early 1930s was an exciting and encouraging time for most African Americans. The air was filled with the expectation of what Booker T. Washington's philosophy of progress promised.

This little book is a pictorial celebration of a community, not unlike so many others in the south, whose stories wait to be told. For Norfolk's African-American community, survival was the goal at all cost, and in that process, the daily life mattered most of all.

One

ANTEBELLUM NORFOLK

In the years before the Civil War, a great majority of Africans remained enslaved, but many were becoming free—some by birth, many others as a result of the 1782 Virginia law that permitted the owner of an enslaved African to free any person s/he chose simply by a process of declaration, which was similar to a transfer of deed. Interestingly enough, the effect was the manumission of a number of enslaved Africans. They were able to purchase their freedom from the money accumulated hiring themselves out as semi-independent contractors. This opportunity was probably only available to those who were semi, or fully, skilled artisans.

Even though obtaining freedom was a possibility for some, freedom seldom meant "free" as it is understood today. Free Africans—recently manumitted or born free—could seldom be assured of obtaining the simplest education, by law. Thus, they were all too frequently unable to read and write. In addition, being free did not guarantee unlimited mobility. As a result of a 1793 Virginia law, each free African was required to register yearly with the local authorities and carry the clerks' certificate of registration at all times on her/his person to be produced upon demand.

Nevertheless, in spite of the possibility of removing one's shackles, full enfranchisement was still many, many decades away. The visual images presented in this chapter serve as a testimony to the few who were able to overcome some of the obstacles. The account of Margaret Douglass reminds us of the price paid by sympathetic European Americans. The Nelson Young family documents and letters provide insight into the daily life of the "free born." The inclusion of photo portraits of the Young family circle of friends and acquaintances helps to put a face to antebellum freedom.

In 1853, Margaret Douglass's 30-day incarceration in the Norfolk City Jail caused quite a stir. The photo here is an advertisement for her book recounting that experience. The story of Margaret Douglass and her daughter Rosa is an interesting one. Mrs. Douglass established a school in her home for "free children of color," primarily as a result of Rosa's experience in tutoring the four children of a prosperous barber, John Robinson. As a South Carolinian, Mrs. Douglass was well aware that it was against the law to teach the enslaved to read and write; however, she did not realize that this prohibition extended to those not enslaved as well. She had often noted that other women of her class ran private schools in their homes for the few free children of color, and she knew of the various churches' efforts in teaching reading and writing in their Sunday schools for the primary purpose of the conversion of souls. She had no reason to believe that her actions would be illegal. So successful were her efforts at the time of her arrest that the enrollment of her school was reportedly over 200.

Aside from the general embarrassment that her arrest and subsequent jailing caused local authorities, this incident also brought to the forefront the inherent conflict between the theology of Protestantism and the laws of the land. This problem arises because one of the fundamental tenets of Martin Luther's thesis was that each believer was entitled to establish a direct relationship with God through his or her reading of the Bible. A basic characteristic of the majority of the Protestant religions of this period was the establishment of literacy among their believers. As a result, the practice of teaching rudimentary reading and writing as a part of Sunday school each week was widespread in Norfolk churches. It was often regarded as an appropriate activity for well-born ladies to engage in as part of their charity work.

This formal photograph of an unidentified woman, along with the others that appear on the following pages of this chapter, portrays the family and friends of Nelson Young. They were found unmarked among the belongings of a descendant of Nelson Young's. Upon careful examination, these images put face to a population that is not frequently written about, but seldom imagined.

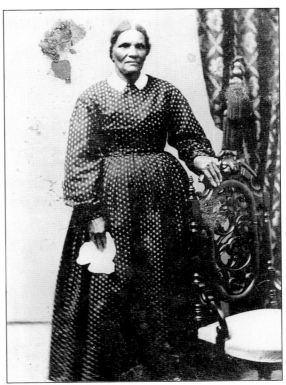

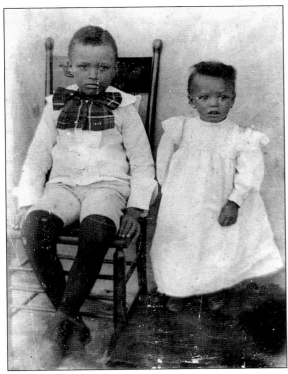

The photo of two young children, sibling no doubt, invites many interpretations. The elaborateness of the boy's outfit and the meticulousness of his hairdo as well as his position in the chair—a kind of enthronement—suggest that he occupies a special place within the family, as heir apparent, perhaps.

Virginia, Norfolk county to wit: At a Court held for Norfolk county the 16th day of November 1857 The Court doth certify upon the testimony of white persons that Nancy Ann Virginia Elliot child of Issiah Elliot and Jemminma his wife is of mixed blood. The aforesaid Nancy Ann Virginia Elliot (now Nancy Ann Virginia young wife of Nelson Young) is of light-indian complexion, has a large scar in the centre of the forehead and one on the right wrist—five feet three and a half inches high was born in the County of Norfolk on the 11th day of October in 1836—I LeRoy G. Edwards Clerk of norfolk county Court I the State of Virginia do hereby certify that the foregoing is a true copy of the order of said Court and that the description of the said Nancy Ann Virginia Elliot has been correctly made by me. Given under my hand and the Seal of the said Court this second day of April 1861 in the 85th year of the Commonwealth. LeRoy G. Edwards

A rather curious document, it appears to be somewhat like a birth certificate for a person who may not have had her birth registered at the time she was born. However, history tells us that this is not just a harmless certificate of birth that every citizen must obtain in a civil society. It is indeed a set of papers with which the person must walk each and every day of her/his life to indicate that s/he was born free and, therefore, can walk about unmolested save for being stopped at will to show proof of his/her status as "free colored."

A serious Mason posed here with his book of Mason. His bow tie is very unusual since it is quite large, unlike any we see today. He appears to be wearing a pocket watch that is attached to a ribbon around his chest.

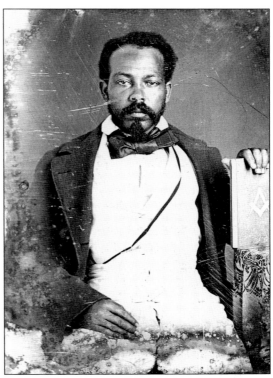

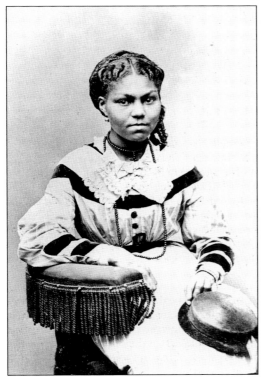

This sweet-faced young woman's very stylized hairdo seems to be a combination of marcel waves, braids, and curls that hang down in the back—a hairdresser's dream, no doubt. Her dress is also fanciful, with velvet stripes on the forearm and a large velvet stripe across the chest.

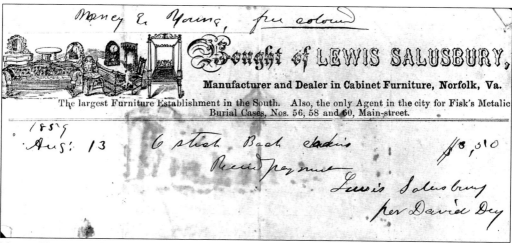

Mr. Nelson Young Jr. Jr.

To the Sheriff of Norfolk County, _Dr._

1852.	Revenue Tax on	acres of Land, valued at $	at 18 cents per $100	- - - -	$
	" " on Personal property valued at $		at 18 cents per $100	- - -	
	" " on Income $			- - - - -	
	" " on	1 Colo Tap— white males over 21 years old at 36 cents each	- - - -	1 00	
	School Tax on	white males over 16 years old, $; School Tax on property $		
	Parish Levy on	1 Tythes at 75 cents each	- - - - -	75	$1 75

Reced pay for Mr Brooks Crocher

This receipt from the Sheriff's Office of Norfolk County is curious. It appears to be a receipt for a colored tax—a tax for being colored??? Well, a careful examination of this receipt reveals that both white males over the age of 21 and over the age of 16 were also taxed. Also, note that the tax for an adult colored male is considerably higher than for an adult white male. What makes this seem odd is that we might presume that white males receive some benefits for paying the tax—school benefits perhaps? However, there does not appear to have been any benefits for the colored male since it was still illegal in 1852 for him to be schooled.

Nancy E. Young, free colored

Bought of LEWIS SALUSBURY,

Manufacturer and Dealer in Cabinet Furniture, Norfolk, Va.

The largest Furniture Establishment in the South. Also, the only Agent in the city for Fisk's Metalic Burial Cases, Nos. 56, 58 and 60, Main-street.

1859

Aug. 13 6 stick Back chairs $3,510

Reced payment

Lewis Salusbury

per David Dey

Nancy Young, Nelson Young's wife, purchased six stick back chairs on August 13, 1859, for what almost looks like $3,510. In looking closely, however, the 5 in 1859 is written somewhat like the 5 in 3,510. It would make more sense also since $3,010 for six stick back chairs at that time would have been quite an amount. It is probably more likely that Nancy Young paid only $3.50 for the six stick back chairs. Another factor contributing to that conclusion is that during this period many people still used the comma where we use the decimal today. In fact, the practice of indicating the decimal with a comma is still in use throughout Europe.

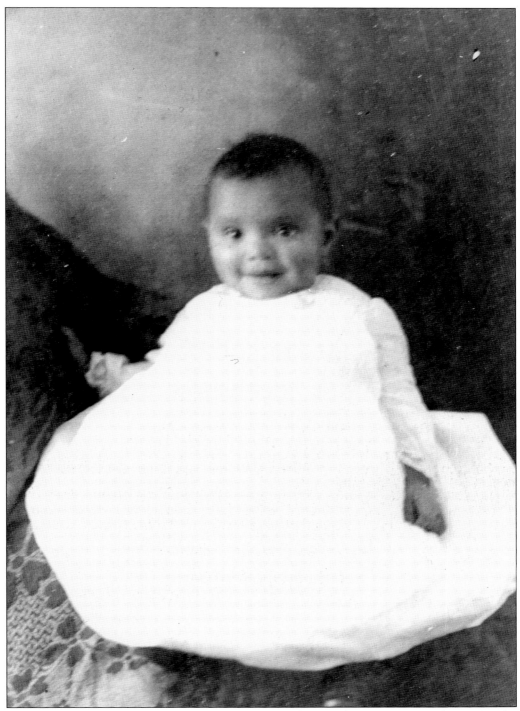

This round-faced baby expresses the joy of life, full of hope and expectation, ready to meet the world. Little does she realize that her opportunities to be who and what she wants are severely limited in the state of Virginia, even if she has the opportunity to be schooled.

Provost Marshal's Office,

Portsmouth, Va. *June 27th* **1864.**

No. *1684*

Permission is hereby given to *Mrs. S. Elliott*

.. to come to PORTSMOUTH and

:turn without molestation or interruption for...... *4*weeks.

Pass limited to *3* miles, direction of

Seols Creek on *Seols Creek* Road.

By Order of Brig. Gen. ~~EDWARD A. WILD~~, *Vogdes*

CAPT. and PROVOST MARSHAL.

During the Civil War, the borough and the surrounding counties were occupied by Union troops. Nevertheless, it was still necessary for those who were enslaved and wanted to move about at any distance from their place of residence to obtain a pass. This particular pass, dated June 27, 1864, permits a member of the Elliot family to travel back and forth between Portsmounth and the borough for a period of four weeks. It is limited to a radius of 3 miles in the direction of Seols Creek (?) along Seols Creek road(?).

The man in the fetching hat gives his full attention to the camera. Who might he have been? What might he have done for a living? Could he have been the member of the Elliot family for whom the pass on the opposite page was issued?

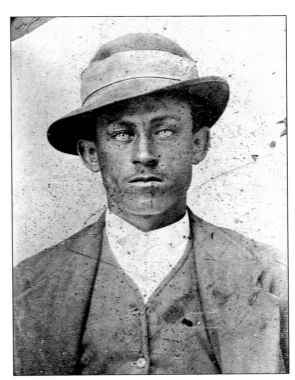

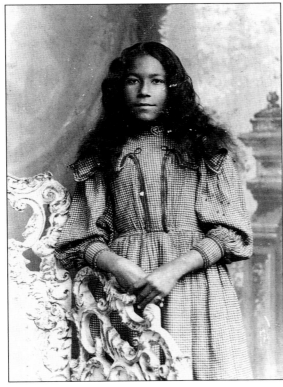

What a charming face she has. This girl, indeed she looks only to be about in her early teens, poses here for a formal photo without formal attire. Was it because she had none, or was this a necessary picture for some official papers?

November the 2nd, 1865 Dear Mrs. Mrs. Young, It was now that I seet myself to inform you of my health I am well and do hope that when this comes to hand it wil find you well and in good health as it leves me well and all the family wel and Do hope that when this comes to hand it will find you well. I have seen sistter Rachel Elliot and she told me to tell you that what you and her was talking about they was nothing out it And she dirsear you to come to Norfolk /Va next sareday and she wil be there to see you if nothing happening She is well and her folks is well sends love to you must excuse me fer not writing you before I rote to a letter and I went to Norfolk and ferget it and that it the resen that you have not got any letter yet. No more at present But I still remain your affectionate Cousan. J.W. Elliot

This is an example of literacy that was achieved by some prior to the period of emancipation. It is evident by the number of phonetic spellings and length of sentences that the writer did not have a great deal of formal instruction in writing. Even so, the convention of paragraph indentation is followed throughout. We might imagine that J.W. Elliot learned to write in Sunday school, as this level of literacy would allow him to read the Bible. What is encouraging here is to note that in spite of the injunction against literacy among Africans and "free people of color," some were able to write and read even if not all of the conventions of literacy were mastered. Clearly, William Young's sister could read.

The name of the man posed here is unknown. What we can see from this image is that he exudes a kind of devil-may-care self-assuredness. Notice his wide-legged stance and seeming lack of interest in his appearance. He seems to be saying, "Well here I am." Perhaps his confidence derives from his occupation or position in the community.

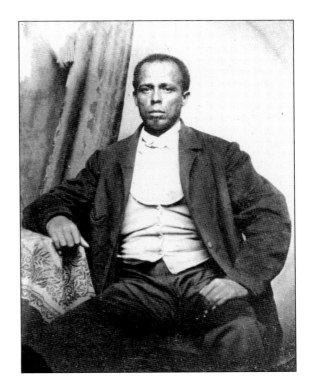

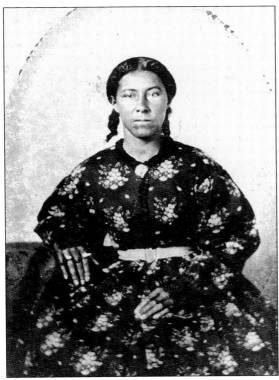

An almost doll-like image, this woman has a tiny waist and short torso. Quite unusual and fascinating are the size of her hands and the length of her fingers. Her digits are very straight, long, and equally proportioned between the base and the forefinger.

September the 8/1864
William young sister near
by young I ask you to do me
a favor if you please I won't
you to gd out to the store
and got me a half dollers
with of watch kegs jest
the sizes of this little
I think that you will find
in this letter and if you
hant find them at the
store you try the slave
smith and got them and
send them to
if you can and to me
and I wont to one of you had
you reether reserved
Nelsons Coles or da
you want me to deal them
and got the money

for them and if hant
atend to that business that
I ask you to do go tell
brother Richard young
to atentoit

Well I am well at this
time and I hope that
these few lines may
find you the same
from William young
your dear brother in Law

brias kegs

Despite injunctions to the contrary, "free persons of color" did learn to read and write, as has been seen on previous pages. Reading and writing were often taught in church Sunday schools or occasionally by a private tutor, maybe a member of a genteel family. It is not known how widespread this ability was. Historian Thomas Bogger estimates in *Free Blacks in Norfolk, Virginia: 1790–1860* that the percentage was not very high due to a number of contributing factors. One was surely the 1805 law that exempted masters of African apprentices from having to educate them in the basic three Rs. This, in effect, rescinded the apprentice law of 1701. Part of the hysteria derived from the fear of insurrection, the 1800 Gabriel incident in Richmond being an oft cited case. It was determined that most of those accused had a wide knowledge of local and international current events, knowledge which one obtains from reading the newspaper. The letters presented throughout this volume reveal that reading and writing were an important method of communication within and between families.

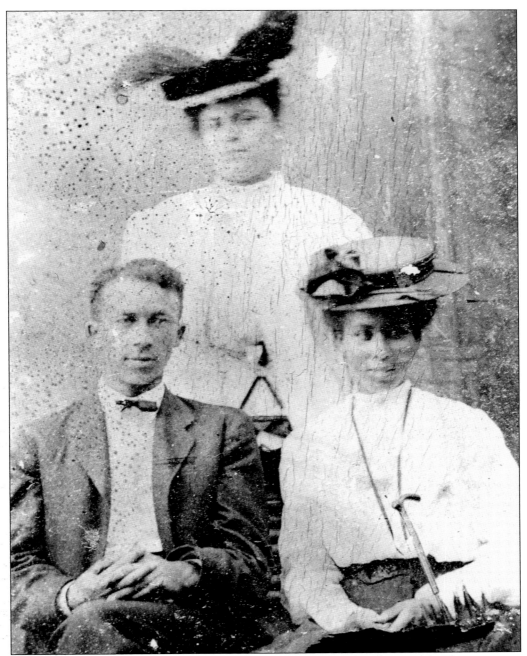

Family bonds were enduring. Three young adults are posed in this photograph. They are most likely siblings. However, it is also quite possible that they are husband, wife, and sister, or husband, wife, and mother-in-law. There are many possibilities. During this time, it was not at all unusual for siblings to maintain their bond throughout their lifetimes. Neither marriage nor relocation would have disturbed it. From the clothing, it can be inferred that these young people were prosperous of sorts and that the idea of taking a picture together provided some sort of enjoyment for them.

October 29 1864 Wilson Warf, Dear sister I now tak up my pen to write you a few lines hoping th will find you in good Ealth at preseant you wanted me to let yu now War your Husband War ded or not Your Husband is dead and bured he was killed on the road win I sent out for him the was dead I haave a littlel money to send you I want you to let me now the best way to send it Genals watts an is family an South all an is famley an how dick young an is famely S no mor at presant from your brother William Young write soon.

This is the second letter we have that was written by William Young. Here, he is writing to his sister, who has apparently written to him inquiring as to the whereabouts of her husband. His answer to her seems somewhat blunt and cold but not unsympathetic. One wonders what the relationships were between these three? What would have accounted for her not knowing about her husband's death? Was he away at war? It was 1864, and the war was still going on. There is much here to speculate about.

Two

FEEDING THE SPIRIT

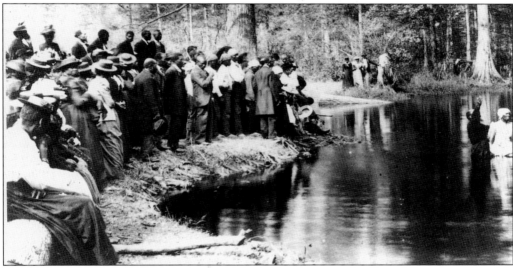

Religion played a major role in the lives of African Americans in the United States, and Norfolk was no exception. During the period of enslavement, it provided an emotional release from the oppression of daily life and hope for a better life in the hereafter. Many of the church songs and spirituals offered consolation ". . . in the sweet bye and bye . . ." "I've been buked and I've been scorned." With emancipation, religion was to become a great source of emotional support, public socialization, economic and educational opportunity, and community affiliation. Even today most African-American Norfolkians identify themselves by their church membership along with their neighborhood affiliation. From the early years of the 20th century, African-American churches have been on the forefront of social change, playing a major role in the fight for voting rights, equal educational opportunity and access, and equitable pay for teachers and other city and state employees. A whole host of other injustices of the 19th and 20th centuries also became the province of the African-American church..

Long before many churches began to baptize by total emersion, it was the custom to baptize "down by the riverside" as is being done in this image. This baptism probably occurred in the postbellum period since the minister is an African American. Prior to the Civil War, most churches, especially Protestant ones, did not ordain African Americans.

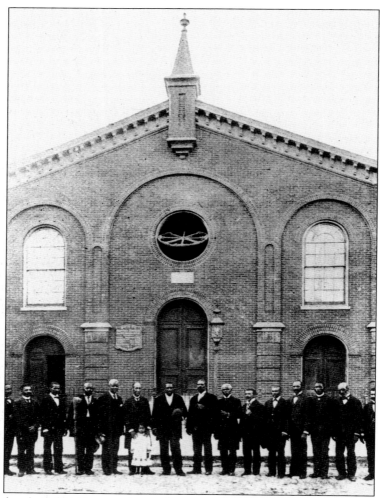

A group of what look like deacons is standing outside of First Baptist Church. This structure preceded the existing church, which is still in use. The history of the Baptist in Norfolk is an excellent example of the conundrum that faced Protestant theology throughout its early years and continues, to some extent, to face Protestant theology even today. Only the select could be saved; however, each believer was obligated to bring salvation to her or his fellow human. And even though salvation could never mean for the enslaved and indigenous peoples the same as it did for the chosen, it was necessary, nevertheless, for them to be saved. And so in Norfolk, the original Baptist church congregation was made up of Europeans, free colored, enslaved, and indigenous peoples all worshiping together under one roof. Legend has it that this congregation was formed by persons who, because of the inconvenience of traveling across the Elizabeth River, requested a letter of dismissal from the Court Street Baptist Church of Portsmouth. In 1800, the newly formed group began having services in a hall on Cumberland Street. By 1805, they were worshiping in the Borough Church (Old St. Paul's Episcopal Church). The congregation grew, and by 1815, there were approximately 280 members. This arrangement continued until 1816 when a about 25 European-American members withdrew to form a European-American-only church—Cumberland Street Baptist Church. By 1830, the original Baptist church in Norfolk, known as First Baptist, began to worship on Bute Street. The structure pictured here immediately preceded the current church building.

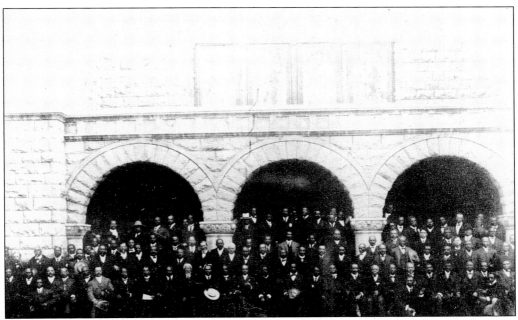

The above picture came without a caption; however, the large group of men arranged here are standing in front of First Baptist Church, Bute Street, the structure built in 1906. There appear to be no European-American members in this group. By this time most, if not all, European-American members had either left to form their own churches or were deceased.

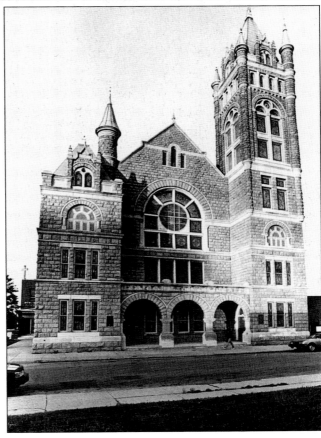

Designed by Tennessee architect Ruben H. Hunt in 1904 and completed in 1906, First Baptist, Bute Street is one of the best examples of Romance Revival-style in the state according to the Virginia Landmarks Register. It is a three-story brick structure with a facade of rough-hewn pink granite trimmed in Indiana limestone.

An Old Norfolk Landmark
Built In 1802

NORFOLK'S
OLDEST
NEGRO
CHURCH

FORMERLY
KNOWN AS
FIRST COLORED
BAPTIST CHURCH

Bank Street Baptist Church

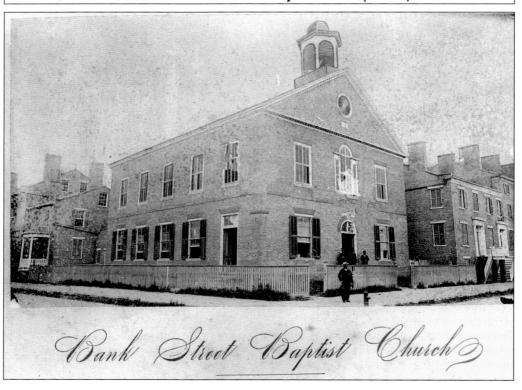

Bank Street Baptist Church

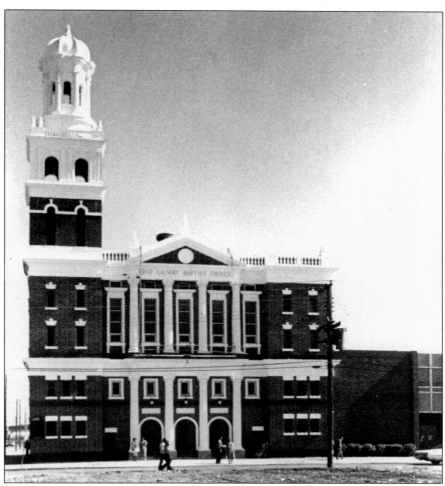

Above: The story is told that when the Reverend Richard Spiller became the pastor of Bank Street Baptist Church, he organized several revivals that resulted in the conversion of over 1,000 people. After a while, the congregation grew so large that the new converts formed themselves into a new church. It became known as First Calvary Baptist Church, pictured here. The four-story church structure, built in 1916, is most notable for its terra-cotta decoration and architectural style.

Opposite above: In 1840, a second group of members withdrew from the First Baptist Church. They were mainly prosperous "free borne and self freed coloreds," although there were some European-American members in the group. This group of believers would purchase the former Presbyterian Church on Catherine Street which was built in 1802. The Catherine Street Church was frequently referred to as the Bell Church because of a regulation that the bell must be rung for the morning and evening services. At this time, due to a number of controversies within the original Baptist church on Bute Street, the use of the name First Baptist was rescinded, and the recently formed congregation on Catherine Street would be designated, First Baptist, Colored, of the City of Norfolk.

Opposite below: There is some confusion as to whether this image is of a remodeled Bell Church or an entirely new structure. The caption on each of the photographs leads to this confusion. It is known that through the years there were several renovations to the church's structure. When the street was renamed Bank Street, the church became known as Bank Street Baptist Church.

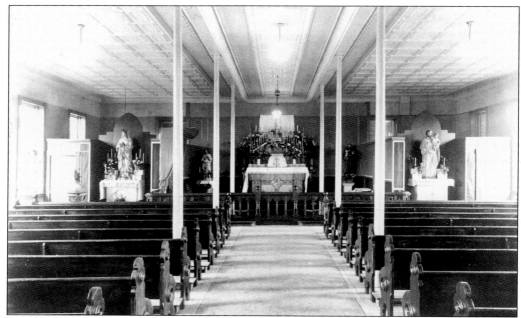

The Catholic church's involvement in the religious life of African Americans dates back to 1860 when an African-American congregation was established in Saint Joseph's Catholic Church on Queen Street. The interior of the church is a very simple sanctuary, with little of the elaborateness that one often associates with Catholic churches.

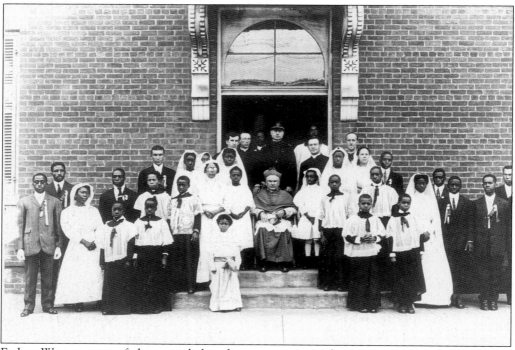

Father Warren, one of the most beloved priests among African Americans of all faiths, is pictured here surrounded by recently confirmed congregants.

After Norfolk's redevelopment plans slated Saint Joseph's for demolition in the 1960s, African-American Catholics began to worship at Saint Mary's in large numbers. Saint Mary, as can be seen from these photographs, is a much more elaborate structure than Saint Joseph's was. Recently, the steeple was taken down and repaired, and the entire building underwent a refurbishing of its facade.

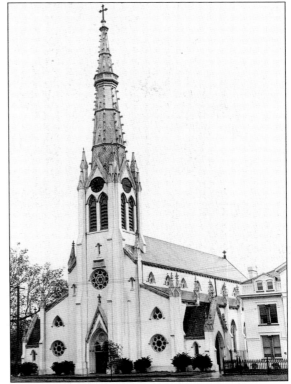

This is an interior shot of Saint Mary of the Immaculate Conception. Built in 1858, it can rival any basilica Europe has to offer. In fact, the church has rather recently been designated, the Basilica of Saint Mary of the Immaculate Conception.

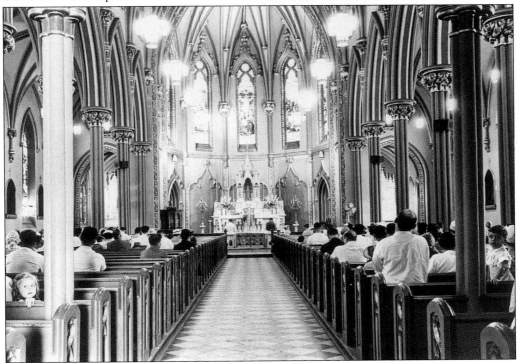

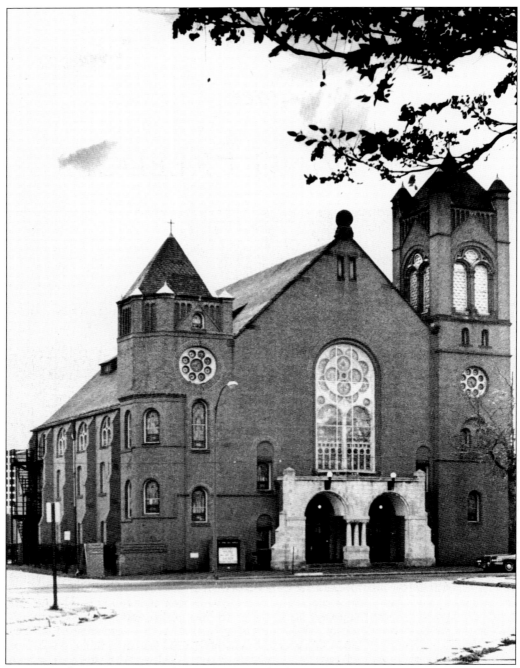

Constructed in 1897, Saint John's African Methodist Episcopal Church is a brick two-story structure with one four-story tower at the western corner and a three-story tower at the eastern corner. A central feature of its facade is the two-story stained-glass window. Norfolk's Methodist Episcopal African-American congregants date back to 1800, when there were approximately 700 in the Portsmouth-Norfolk area, and among their membership were many of the prominent leaders in the struggle for equal opportunity and equal access.

Three

SURVIVING FREEDOM

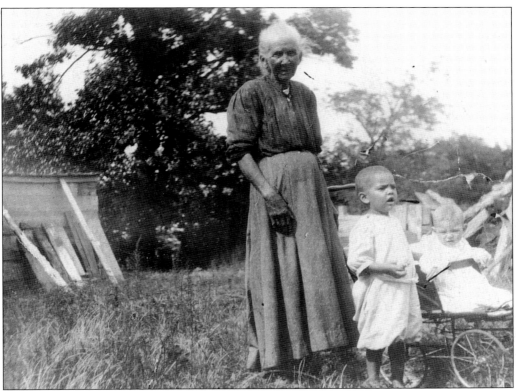

The images in this chapter are comprised of documents as well as individuals. The first set details Thomas and Nancy Ridgeway's life in the postbellum period, and the second set sheds light on the personal use of literacy and the level of sophistication that were attained by Mary Lou Stith and her circle of friends. Others are of unidentified individuals from the postbellum period, some who may very well have been enslaved or have purchased their freedom or been born free. The remaining ones are of organizations established for the purpose of providing for the welfare of individuals in need.

This woman may have been a grandmother who lived in the country rather than in the borough itself. Her yard, where she tends her two small grandsons, appears to be quite spacious. Notice the tall grass, which would be more typical of life in the country than the manicured lawns of the city.

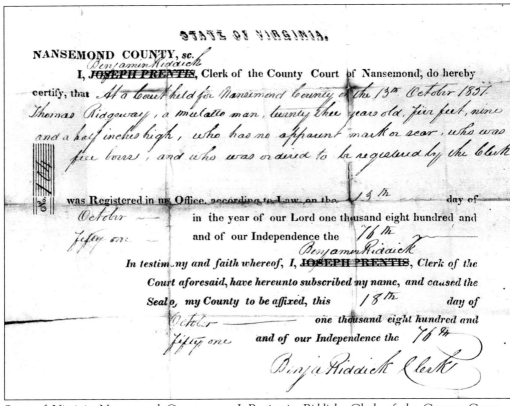

State of Virginia Nansemond County, sc. I Benjamin Riddick, Clerk of the County Court of Nansemond, do hereby certify, that At a court held for Nansemond County on the 13th of October 1851. Thomas Ridgeway, a mulatto man, twenty -three years old four feet, nine and a half inches high, who has not apparent mark or scar, who was free borne and who was ordered to be registered by the Clerk. Was Registered in my office according to the Law on the 13th day of October in the year of our Lord one thousand eight hundred and fifty one and of our Independence the 76th. In testimony and faith whereof, I Benjamin Riddick, Clerk of the Court aforesaid, have hereunto subscribed my name, and caused the Seal of my County to be affixed, this 18th day of October one thousand eight hundred and fifty one and of our Independence the 76th Benja Riddick Clerk

Once yearly, each "free person of color" was required to register with the County Clerk's Office. Registration documents were necessary, as they provided a mechanism for the local government to know officially who was free and who was not. General physical appearance was not a sufficient enough indicator of free status, contrary to popular notions of freeness being correlated with skin color. One's free status in Virginia was determined solely upon either having been manumitted by a transfer of deed or by having been born to a set of free parents. Anyone claiming free status and unable to provide legal documents indicating such faced the possibility of being attached to an enslaver and sold.

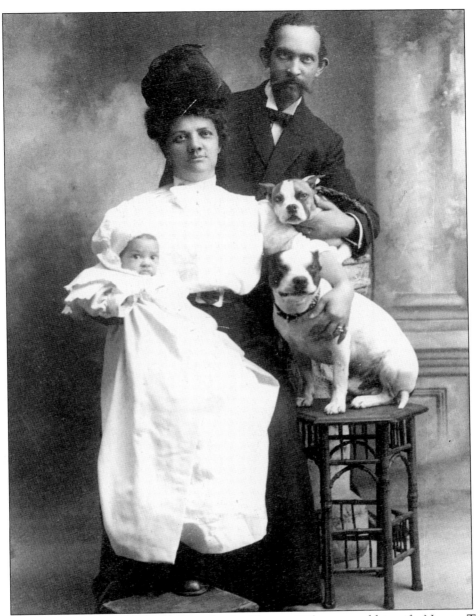

The couple in this photograph is believed to be Thomas Ridgeway and his wife, Nancy. Their story begins much earlier in antebellum Norfolk. Both Mr. and Mrs. Ridgeway were "freeborn" (in an earlier section we saw their registration papers). Their parents were more than likely not born free but were able to secure their freedom through contracting out their labor in exchange for wages, which could be saved to pay the enslaver for their freedom.

Thomas and Nancy Ridgeway appear to have been very prosperous, as evidenced by their appearance and their possessions. They are posed with their child, a son, and their dogs. What strikes one as unusual here is that they appear to be giving equal affection to both their child and their dogs. Note that the pets are not lying down on the floor at their feet but are instead up on pedestals; clearly they are beloved house pets.

WESTERN BRANCH.

Mr. Ridgeway Thomas **Dr.**

1874. To Treasurer of Norfolk County :

	STATE TAX.		SCHOOL TAX.		COUNTY TAX.		TOTAL.	
	Dolls.	Cts.	Dolls.	Cts.	Dolls.	Cts.	Dolls.	Cts.
To **20** acres of Land								
Value $ **400**	2			80	1	80		
" Property, &c., value $	1					50		
" Capitation Taxes								
State Tax 50c. per $100.	3			80	2	30	6	10
County do. 45c. per $100.								31
School do. 20c. per $100							6	41
Received payment,								

J Butt Collect

$65 00 Portsmouth, Va., *Oct 31st* 1876

On demand days after date, for value received, We promise to pay to
the order of *W B Ramsey* without offset.
Fifty Five Dollars,
Payable and negotiable at the office of BAIN & BROTHER, BANKERS, in Portsmouth, with interest
at the rate of Eight per centum per annum from *date* . The makers and
endorser, each hereby waive the benefit of the Homestead and all other Exemptions as
to this debt, evidenced by this Note.

 Credit the maker

Witness Thomas X Ridgeway jr
 Nancy X Ridgeway

WESTERN BRANCH.

Mr. Ridgeway Thomas **Dr.**

1874. To TREASURER OF NORFOLK COUNTY:

	STATE TAX.	SCHOOL TAX.	COUNTY TAX.	TOTAL.
To **20** acres Land, value $ **400**	$ 2 00	$ 80	$ 2 00	$
To Property, &c., value $				
To Capitation Taxes				
State Tax, 50c. per $100.				4 80
County Tax, 50c. per $100.				24
School Tax, 20c. per $100.				
Received payment,				

A F Peak collector Treasurer

WESTERN BRANCH.

Mr. Ridgeway Thos. (Col) **Dr.**

1875. To TREASURER OF NORFOLK COUNTY.

	STATE TAX.	SCHOOL TAX.	COUNTY TAX.	TOWNSHIP TAX.	TOTAL.
To **20** acres Land, value $ **400**	2 00	80	1 60		3 71
To Property, &c., value $ **142**	71	29	57		1 09
To Capitation Tax	1 00		50		2 69
State Tax, 50c. per $100.	3 71	1 09	2 67		7 47
County Tax, 40c. per $100.			Comm	$	38
School Tax, 20c. per $100.					7 85
Received payment,					

W W Tucker Dep Treasurer.

Top image, opposite page: It is possible to infer from the body of materials collected that Thomas Ridgeway and Nelson Young were related. Some of Nelson Young's family papers were in the possession of Thomas Ridgeway's descendant, S.T. Ridgeway. While this may not necessarily prove the connection, the possibility for speculation is ripe. The interesting question is whether this receipt for 20 acres is the same 20 acres of land that Nelson Young owned. Or, did Thomas Ridgeway purchase his own 20 acres in the Western Branch? It is known that these 20 acres remained in the Ridgeway family into the 20th century. Saintilla Ridgeway Thomas and Nancy's progeny still owned these 20 acres in 1916.

Second image from top, opposite page: This receipt is for a loan of $65 from the Bain and Brothers Bankers in Portsmouth. There is no indication here as to what type of loan it was or what it was for. There are, however, several things here that are worth noting, for example, the unusually high interest rate on the loan. Nowadays, an eight percent loan might seem normal or, depending upon the state of the economy, low. However, an interest rate of eight percent in 1876 appears to be more a loan shark rate rather than a bank rate. Or is this the rate for African Americans? One wonders. Another curious observation is that the lender is actually W.E. Kember, not the bank itself; the bank is only the holder of the note.

Further, if we look very carefully at the receipt, we see that the signature was signed by the same person, and in the middle of each there is an X mark between the first and last names with the notation "his mark" and "her mark." It would not be too farfetched to conclude that neither Thomas nor Nancy could read or write. Not being able to read or write makes their prosperity that much more interesting. Both were born free, and from their appearance and evidences of their lifestyle, it seems odd that they would not be literate.

Bottom two images, opposite page: Pictured are Thomas Ridgeway's 1874 and 1875 tax receipts for the property he owned in the Western Branch. His papers show a continuous payment of real estate tax for the 20 acres over a period of 15 years. What Mr. Ridgeway did for a living is not known, but it might be assumed that he was a farmer of some sort. He might have been an artisan who rented out his land for others to farm, or he might have lived on some of it and allowed others to sharecrop. It is certainly interesting to speculate since the restrictions that were imposed upon him both before and after the war were quite considerable. What Thomas Ridgeway made of those restrictions is important.

Saint Tilla Ridgeway, Exty

To ALVAH H. MARTIN, County Clerk of Norfolk County, Dr.

1910

Nov. 7" To tax & fee in matter of probating
will & qual. as Exty of estate of
Nancy Ann Virginia Ridgeway $7.00

RECEIVED PAYMENT, Alvah H. Martin
 COUNTY CLERK.

 C.P.

This is a 1910 probate receipt for the estate of Nancy Ann Virginia Ridgeway. Her daughter, Saintilla Ridgeway, was the executrix of her estate, which suggests that her father, Thomas, predeceased her mother.

$ 8.95 [RECEIPT TO BE GIVEN WHERE LAND IS REDEEMED.]

Office of the TREASURER OF NORFOLK COUNTY VIRGINIA.

Oct. 29 , 189_

Eight Received of Thos Ridgeway
 Dollars ninety five Cents.

on account of the redemption of 20 acres land returned delinquent for the non-payment of taxes and County Levies by the Treasurer of Norfolk County, for the year 1894

Acres as follows :

State Tax, . $2.94
County Levies for all purposes, 5.51
Interest, . 35
Expenses, . 15

 Total $8.95

 S.W. Lyons , Treasurer.

Apparently, Thomas Ridgeway did not pay his property taxes for some time. This receipt is for the redemption of the 20 acres of land in the Western Branch. Eight dollars and ninety-five cents seems to be such a small amount to have been taxed.

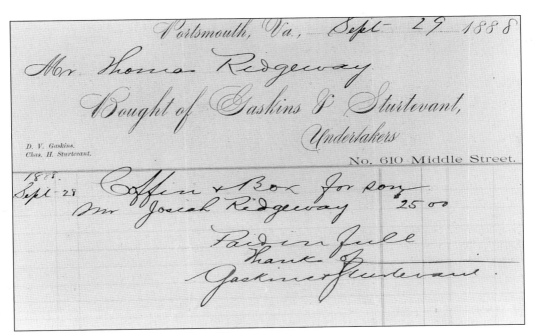

Here is a receipt for a coffin and box. Thomas and Nancy's son, Joseph, died while still a young child. Could he have died from some childhood disease?

A 1916 draft of a lease agreement between Saintilla Ridgeway and G.H. Innis for the rental of the 20 acres in the Western Branch appears to have shrunk to 18 and 3/4 acres of land by this time. What happened to the other 1 and 1/4 acres? Had it been sold? Did the Ridgeways live on it?

Miss Mary Lou Stith, a schoolteacher, was rather typical of many in her social set. She was fully literate. Throughout her very long and productive life, she maintained a correspondence with a number of friends and colleagues. The letters on the following pages reveal a level of literacy and sophistication of lifestyle unimagined for the time period.

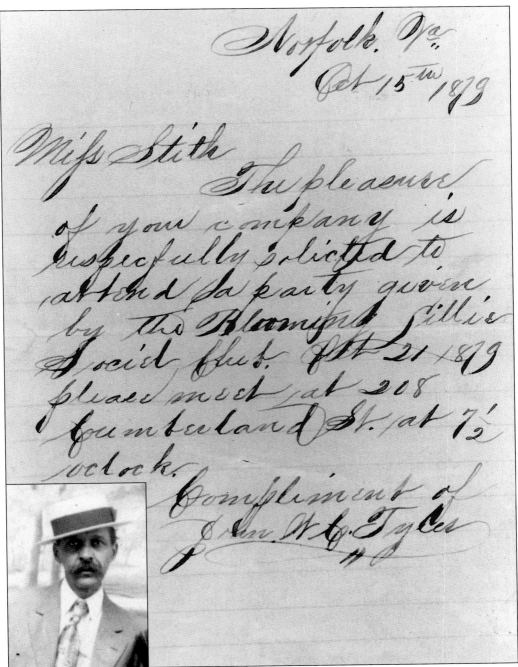

Norfolk, Va. Oct 15th, 1879 Miss Stith, The pleasure of your company is respectfully solicited to attend a party given by the Blooming Cillie Social Club Oct.21st.1879. Please meet at 208 Cumberland St. at 7 1/2 o'clock. Compliments of John W.C. Tyler

This is an 1879 invitation from a schoolmate and admirer, John W.C. Tyler, who Mary Lou Stith married many many years later.

Grand Hotel , Aug. 29, 1890 Pt. Elizabeth So. Africa My dearest Lue, Not many days ago I received your most welcome letter. I need not say how very glad I was to hear from you for you know it always gives me pleasure in its most pleasant form. Lue, I am on the go all the time. The longest stay that we made, has been three weeks. So you can see we do not tarry long in one place. It worries me very much, because it makes it so long before we can get our mail. It has to be sent to us from these different places and I fear some of our mail gets asstray. I have not heard from Aunt Georgie since I left America. Will you please ask them about it and let me hear when you write to me. I am going to send her a letter today . . . Lue, I wanted to send you something nice, real nice, but I find that you will have to pay duty on anything I might send, except something small enough to get into an envelope. So I have decided to bring you something when I come . . . I am traveling through the southern part, and I enjoy it very much. I see many peculiar sights, it is indeed a treat to have the opportunity of seeing the different ways in which people live in this world. After we finish going through the different parts of South Africa, we then go to Australia. I presume it will be about January 1891 . . . Lue, I must close now as I have to attend a reception this evening. Address your letter as before to Cape town c/o Mr. O.M. Me Adoo, Manager of Virginia Concert Company. Love to all. I am yours very lovingly, Mannie (?)

This is a most interesting correspondence. Apparently, Mannie is on a singing tour or a theater tour in that part of the world. It is hard to imagine what famous singing star he might have been. Obviously, Mannie and Lou were good friends, perhaps childhood friends, and they traveled in the same circles.

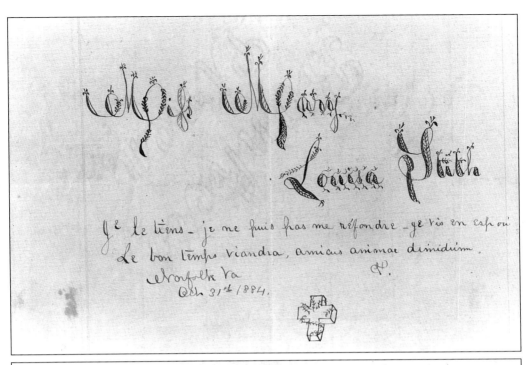

Miss Mary

Louisa Stith

Je te tiens _ je ne puis pas me répondre _ je vis en espoir
Le bon temps viendra, amicus animae dimidium.
Norfolk Va
Oct 31st 1884.

Translation from the French,
I hold it _ I cannot alter my opinion
I live in hope that the good time will come
you shall be a friend as dear to me as my life
(over)

Et in cœlo mori _ Latin,
I know the secret of your heart,
Mon Belle Femme, _ French
My Beautiful (or Handsome) Woman,
(over)

This 1884 French note was from a pal around the time when the level of education that would have made this possible was just getting started here in Norfolk. Who is this friend? Where and how did he become literate in French? These are interesting questions 20 years after emancipation.

What is interesting here in both of these photographs is the collar styles. The man is wearing a wingtip collar with a full straight tie. Nowadays, this type of collar would more than likely be worn with a bow tie. Also, note the vest; it is a wrap pattern rather than the straight button front type that is familiar today.

Again, here is a high stiff collar. Also of note are the items of jewelry: the chain necklace watch, the absence of earrings, and the rather wide lapels on the jacket of this unidentified woman. She evokes an image of a woman who went out to work, a teacher perhaps. Would that have been possible?

This woman faces the camera as if facing a friend, as she seems very relaxed. She is wearing an empire-style dress ornamented by a cameo broach, a string of beads that compliments the dress that appears to have additional beading across the bodice. Fanciful, isn't it?

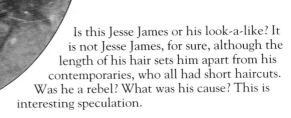

Is this Jesse James or his look-a-like? It is not Jesse James, for sure, although the length of his hair sets him apart from his contemporaries, who all had short haircuts. Was he a rebel? What was his cause? This is interesting speculation.

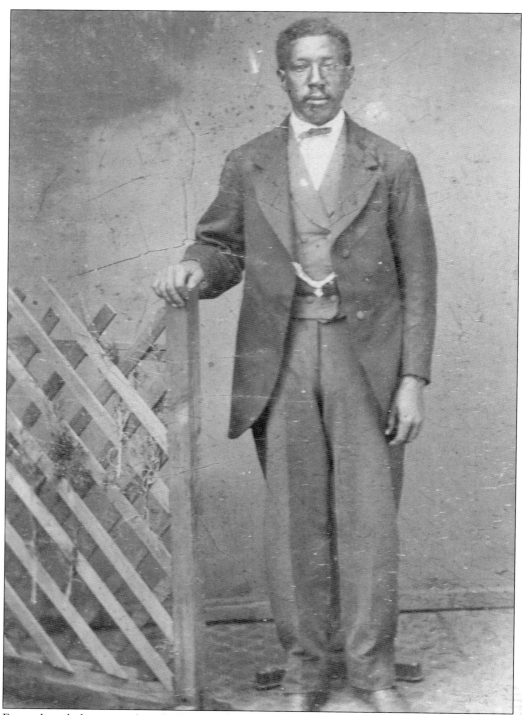

Even though he is unidentified, this man might be a relative of the owner of this set of photographs. He is rather serious looking, and he probably occupied an important position in his community. Note his stance, his pocket watch, and his spectacles.

This young woman appears to be dressed in a contemporary fashion. Her double strand of pearls, the frill of her collar, the pearl ear studs, the hair band, and the general hair style suggest that conclusion. Her photo was found in the group of photos from the postbellum period.

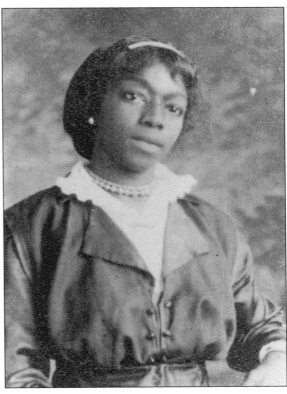

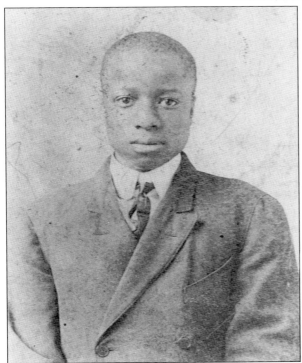

A charming young man seems serious, but unafraid of the camera. One wonders what his occupation might have been? Was he a student, a worker, a parent, and/or a husband?

45

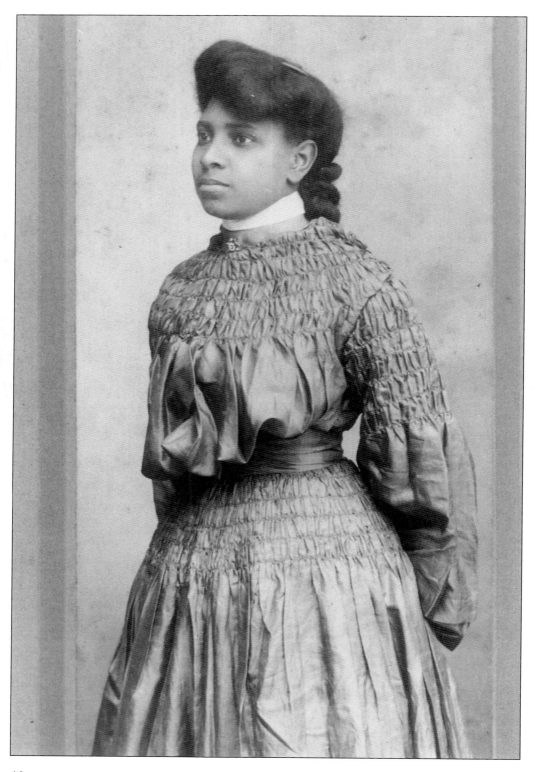

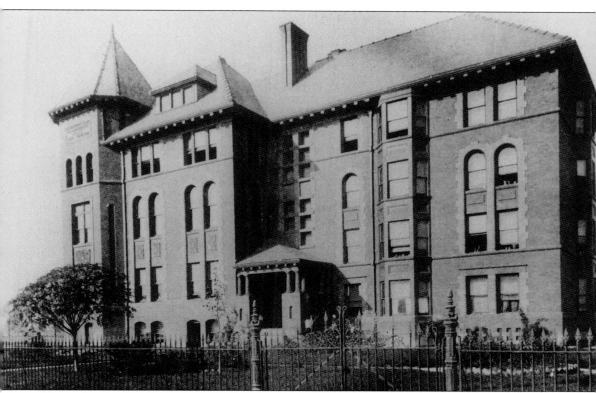

Above: Pictured is the Phyllis Wheatley Branch of the YWCA of Norfolk. In 1890, a group of Norfolk women established an auxiliary to the William A.. Hunton YMCA, which is the oldest independent African-American "Y" in the country and the second oldest "Y" in the United States. On October 15, 1906, the Women's Auxiliary applied for membership to the National YWCA. Their charter was accepted for membership in 1908, and the Phyllis Wheatly Branch began their activities on Bank Street. They were later to move into the building pictured here as they outgrew the previous sites. By 1920, the branch became a branch of the Central YWCA. In 1928, the Phyllis Wheatly Branch was included in the association's annual budget for the first time, making it a full-fledged YWCA branch.

Opposite: The young woman is wearing a dress with a considerable amount of gathering detail or smocking on it. Just glancing at the image, it appears that she is wearing a turtleneck sweater underneath. It is not, however, a turtleneck sweater, but instead a scarf wrapped several times around her neck as if it were a necklace. There is also a broach at the top center of her bodice. She might be dressed for some sort of festive occasion or just for a simple activity; it is really hard to know.

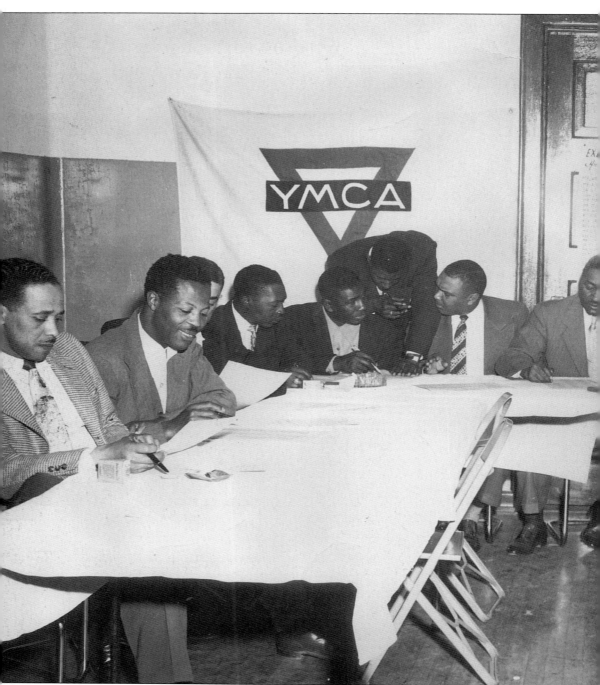

Pictured here is a board of directors meeting for the Hunton YMCA. The Norfolk Hunton YMCA is credited with being the oldest independently owned African-American YMCA in the United States and the second oldest YMCA in the country. As a result of its concern for the plight of the freedman, the International Committee of the YMCA hired Henry Brown to go south to work in the field. He did so for ten years, concluding that the work among African

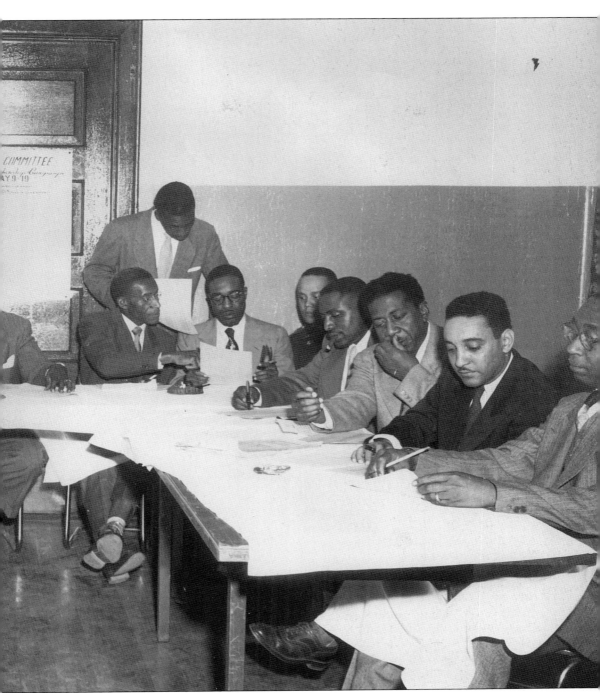

Americans would best be done by one of their own kind. In 1888, William Alphaeus Hunton was offered the position of general secretary of the colored association in Norfolk. Hunton served in Norfolk for three years before being selected to become the first non-European-American secretary of the International Committee of the YMCA.

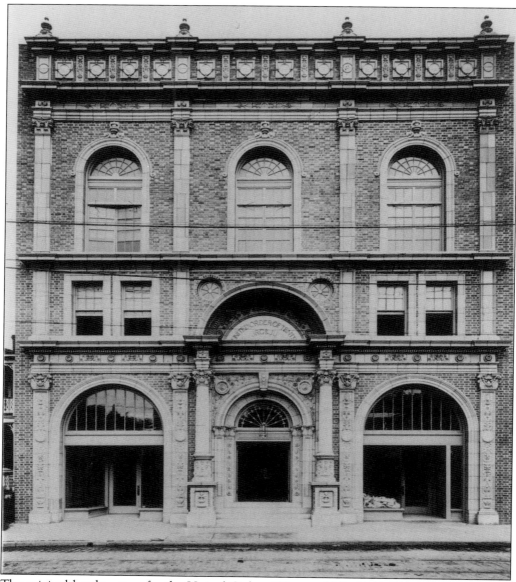

The original headquarters for the United Order of Tents of J.R. Giddings and Jollifee Union is pictured here on Church Street. The Tents, as it is sometimes colloquially known, is an African-American Christian fraternal benevolent organization. It was organized in 1867 by two formally enslaved women, Annetta M. Lane and Harriet R. Taylor. Originally incorporated as the J.R. Giddings and Jollifee Union after the names of the two European-American abolitionists who assisted with the incorporation, by 1912, it had become popularly known as "The United Order of Tents" after the underground railroad custom of providing tents for those escaping enslavement. The United Order of Tents has the distinction of being an exclusively female owned, operated, and directed organization. The Southern District 1, in which Norfolk is located, provides services to the African-American community in the southeastern part of the nation, which includes North Carolina, Georgia, District of Columbia, Maryland, and Virginia.

Four

ESTABLISHING LITERACY

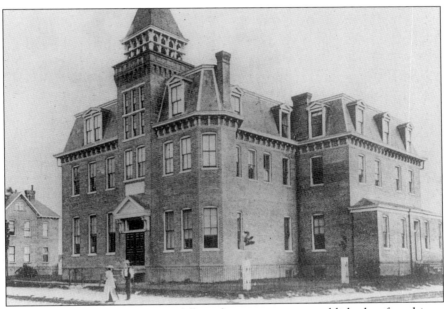

Once the Civil War was over in Norfolk and emancipation established enfranchisement for all Africans—the former free borne, enslaved, and self freed—the process of becoming one with the nation began. Freedom posed a number of challenges—earning a living, establishing a political voice, and becoming literate. The dismantling of the former structures, which had relied upon and supported cheap abundant labor, restrictive social practices, and the benefits of illiteracy, would have an impact upon and require the involvement of the former enslavers as well.

The question now became, how to provide for full participation of future generations in the process of becoming American. One key factor was the establishment of full literacy. Because it had been prohibited by law in Virginia to teach the enslaved, free borne, and self freed to read and write, for the first 60 years of the 19th century, literacy was a highly contested arena. There were no official schools for African-American children in Norfolk—no official process by which literacy could be established and maintained.

The above building is Norfolk Mission College, founded in 1883 by the General Assembly of the United Presbyterian Church. Its mission was ". . . to prepare young men and young women so thoroughly that they may be a power in the uplifting of their own people." Reverend Matthew Clarke and his wife were appointed as missionaries and became principal and teacher along with a Miss Ella Smith, another teacher.

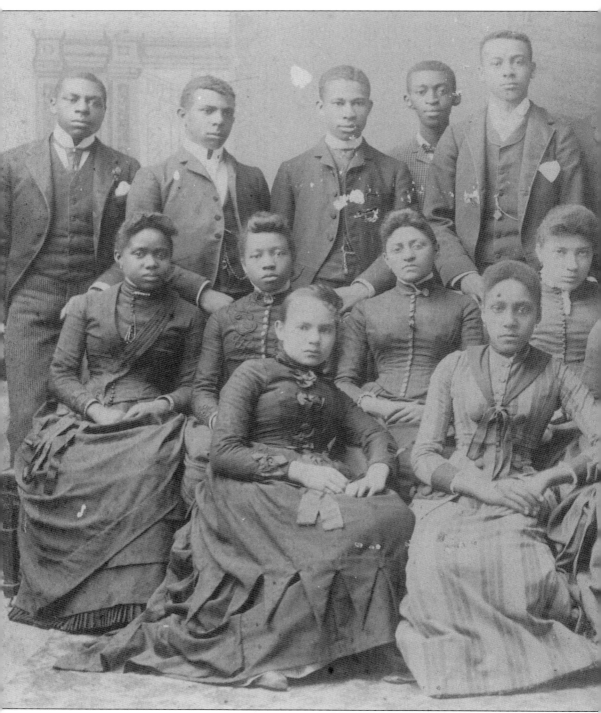

The second graduating class of Norfolk Mission College is pictured in 1889. They are as follows, in alphabetical order: Gertrude Broughton, Mary Boyd, Robert H. Cross, Sallie Cotton, Uthamia Davis, Carrie Fuller, Corine Gibson, Amanda Ganey, Byron Johnson, Rosa Jessups,

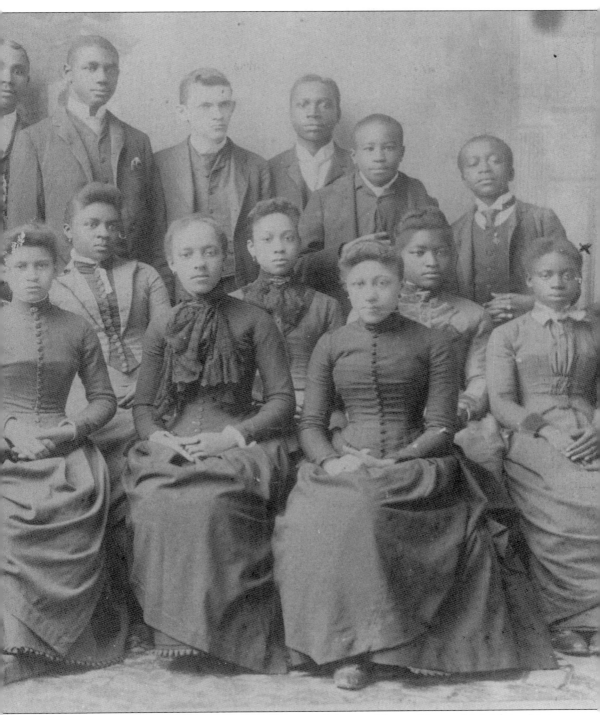

Samuel Jones, Sudie Kemp, Richard McPherson, Solomon Moore, Horace N. Melvin, Lizzie Reid, Elizabeth Ruffin, Willie E. Smith, William E. Smith, Sallie Stith, Annie Tucker, William R. Williams, James R.F. Wilson, and Isaiah Wright.

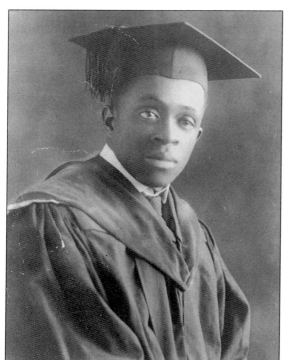

William Miller, a Norfolk Mission College graduate, is photographed here for his 1916 graduation from Howard University.

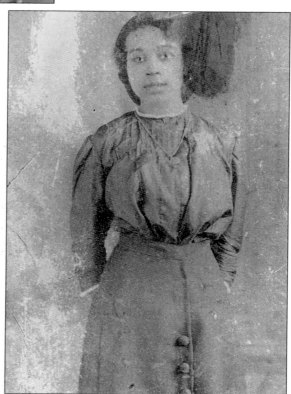

Susie Brown is posing for her 1912 graduation photograph.

Norfolk Mission College

1886

COMMENCEMENT,

College Chapel,
WEDNESDAY, MAY 19th, 8 P. M.

Labor omnia vincit.

Barcroft, Printer, 83 Main St.

ADMIT ONE.

PROGRAMME.

ANTHEM. Sing aloud unto God our strength.

PRAYER.

MELODY..Did you hear my Jesus when He called you ?

SALUTATORY.......….......The Truly Great.
WILLIE E. SMITH.

ESSAY. The Advantages of a Good Education.
ANNIE E. TUCKER.

DUET—Those Evening Bells.........*Carl Merz.*
SALLIE F. LANE AND MARTHA F. SMITH.

ORATION...Jamestown and Plymouth Rock.
JAS. E. JAMES.

A SHAKESPEAREAN COLLOQUY..By ten young ladies.

SOLO—Thou art so near and yet so far... *Reichardt.*
SARAH E. MCCOY.

RECITATION ... The Mantle of St. John De Matha.
FRED. N. CARTER.

DECLAMATION..... The Fisherman's Prayer.
MILES MOORE.

MELODY.............He locked the Lion's Jaw.

The graduation program for the May 19, 1886 Commencement is pictured. The curriculum, which was both rigorous and comprehensive, required all students to take writing, reading, arithmetic, Latin, Greek, and Hebrew. In addition, boys were required to take printing, chair caning, and manual training, including the proper use of tools in the "manufacture and repair of household necessities." The additional courses for girls were sewing and cooking. It was the thinking at that time to educate the whole person so that by the time a student graduated, s/he would be well rounded and able to support him/herself at either a trade or in a profession. To ensure that all students would be able to attain this goal, training in the classical studies of Western Europe and Classical Greece, along with training in practical domestic and industrial arts, was required, and mastery to a certain level was insisted upon. As a part of their courses, students worked on actual projects that the school contracted for that purpose. In printing, for example, students became so adept that the school had a hard time keeping up with the volume of work requested.

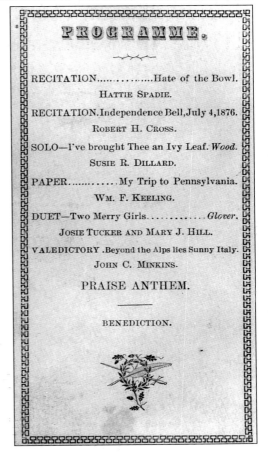

PROGRAMME.

RECITATION......…......Hate of the Bowl.
HATTIE SPADIE.

RECITATION. Independence Bell, July 4, 1876.
ROBERT H. CROSS.

SOLO—I've brought Thee an Ivy Leaf. *Wood.*
SUSIE R. DILLARD.

PAPER...…......My Trip to Pennsylvania.
WM. F. KEELING.

DUET—Two Merry Girls............*Glover.*
JOSIE TUCKER AND MARY J. HILL.

VALEDICTORY .Beyond the Alps lies Sunny Italy.
JOHN C. MINKINS.

PRAISE ANTHEM.

BENEDICTION.

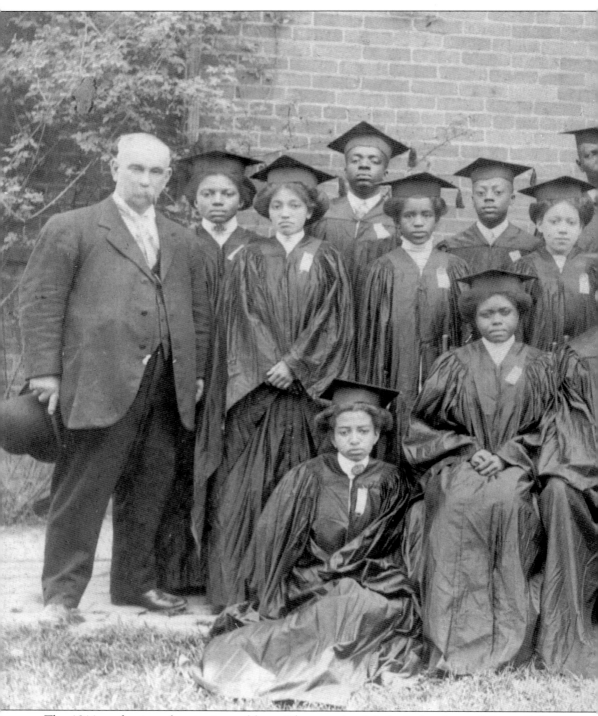

The 1911 graduation class is pictured here. They are, in alphabetical order, as follows: Sallie Allen, Clarine Archer, James Billups, Ruth Bates, Annie Brehon, Sallie Carr, Alfred Collins, Cornelia Dawley, Martha Farmer, Lawrence Harrison, Mattie Hodges, Willie Miller, Sallie

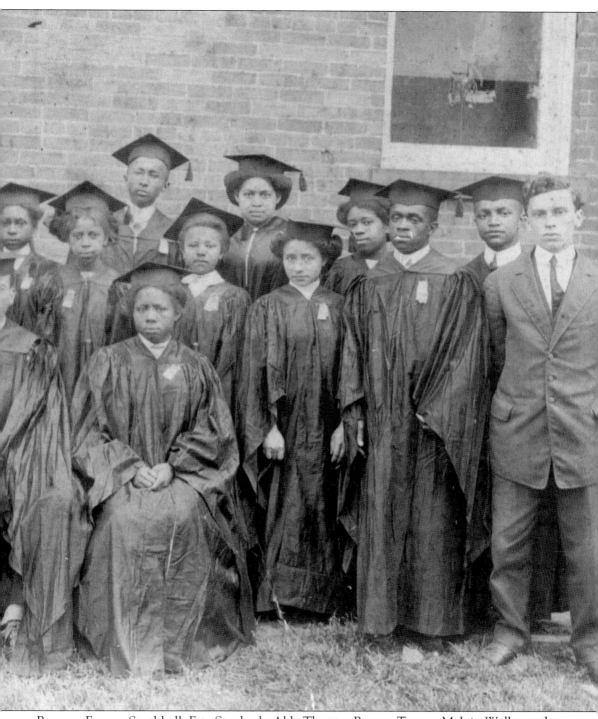

Ramsey, Eugene Southhall, Etta Stanback, Alda Thomas, Rosena Turner, Melvin Walke, and David Wilson.

This would have to be the 1915 girls basketball team. There was probably a boys team also; however, no pictures were found. One wonders how they could have played wearing their school uniforms. It seems like so much clothing—how different from the uniforms of today.

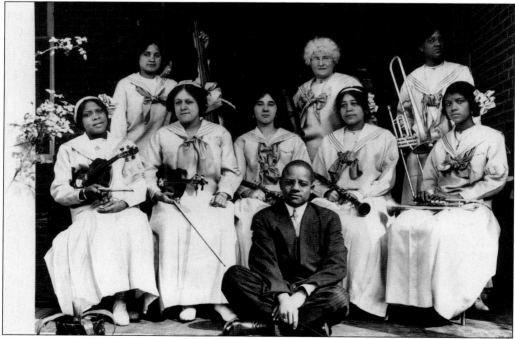

The fellow seated in the center was probably the conductor of the girls' band, and the woman in the second row center the faculty advisor. How odd it seems that at one time there was such a widespread sexual division of extra curricular activities. Nevertheless, it has not been so very long ago that this practice was eliminated.

The 1912 graduating class is pictured here. Among the students are George Brown, Grace Brown, Susie Brown, Sheppard Collins, Lola Coston, Chester Crumpler, Laura Felton, Rosa Gramby, James Hale, Amanda jackson, Leola James, Athur McCoy, Ethel McCoy, Emma Ruffin, Jessee Sawyer, Hattie Simms, Hazel Sykes, and Adella Wells.

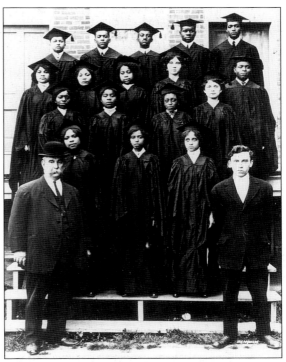

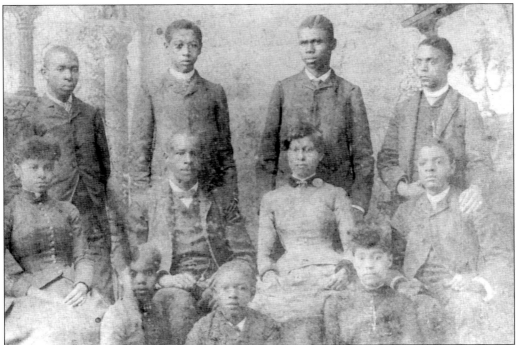

Whether or not this is a graduation class photo is not known. From the clothing style and the small number of students, it looks as if it was one of the earlier classes. It might have been one of the clubs and not a graduation class at all; the photograph came without an annotation.

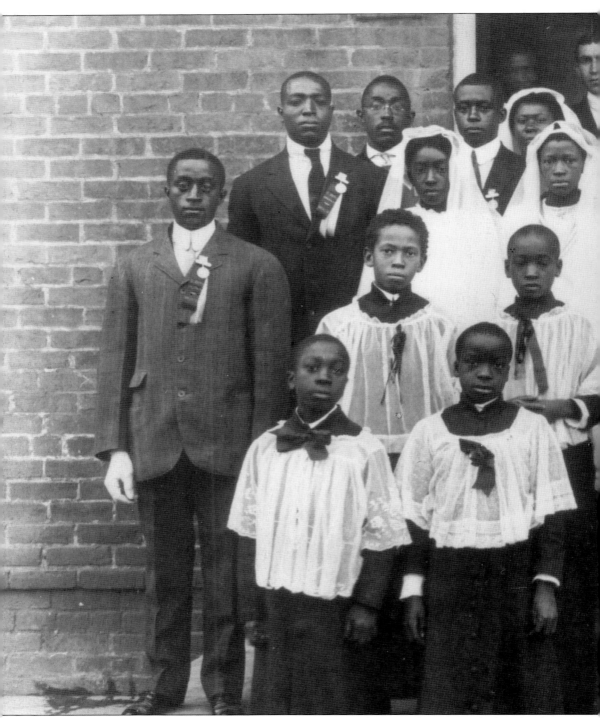

This confirmation class is of Saint Joseph's Colored School, one of the first Catholic schools to be established in Norfolk. It was opened in 1889, which, according to Raymond J. Mattes Jr., predated the opening of Holy Trinity Catholic High School by 41 years (1930) and Norfolk

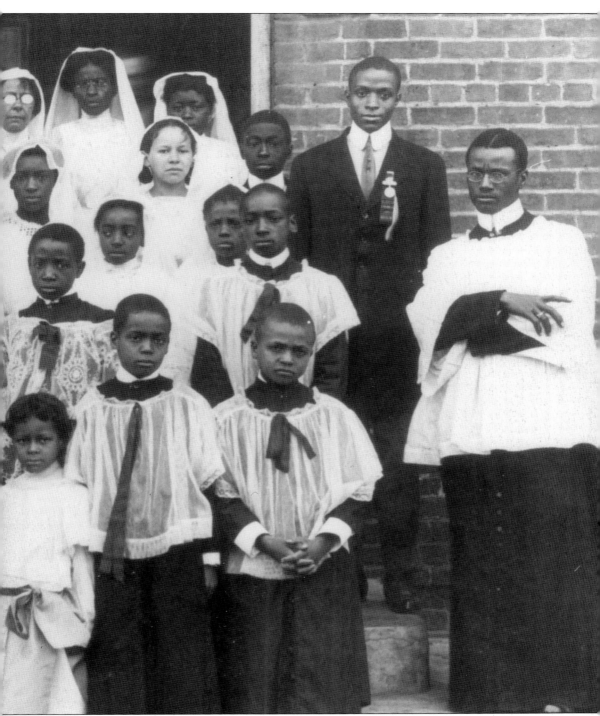

Catholic by 51 years (1950). Most of the teachers at Saint Joseph's were from the Convent of the Franciscan Sisters, who established a convent in the 700 block of Monticello Avenue.

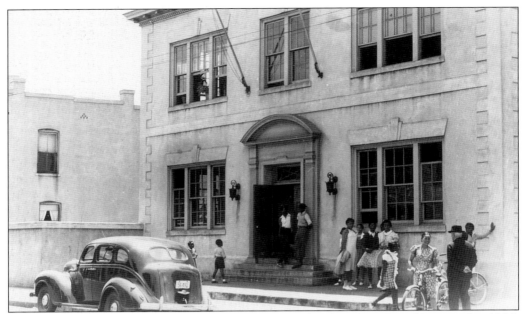

Students are standing outside the entrance of the school. When Saint Joseph's opened in 1889, it occupied a building on Brewer Street. By 1893, having outgrown that facility, it moved to a new building on Queen Street where this photograph was taken.

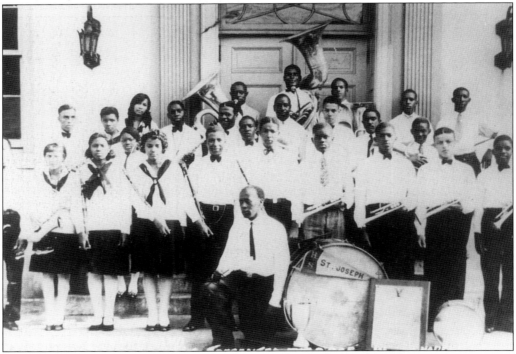

A more recent school band is pictured in front of the final school building on the corner of Freemason and Cumberland Streets. This building was demolished sometime in the 1960s to make way for Norfolk's urban renewal.

This is a 1914 newspaper article account of the reunion celebration for the students and faculty of Saint Joseph's Colored Catholic School.

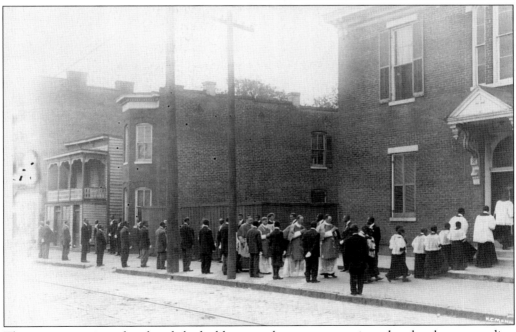

This procession into the church looks like a regular mass procession, the alter boys preceding the priest into the sanctuary. It may have been a special occasion, however. Those who would remember it are long gone, or their memories of these days, while strong, are only impressions and details faded like an old photograph from which this was taken.

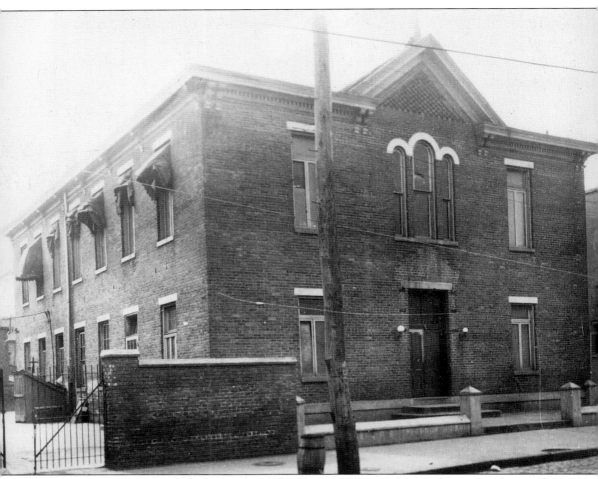

Saint Joseph's Colored Catholic Church building is all boarded up and awaiting the wrecking ball of the Norfolk Housing and Redevelopment Authority. The building has been stripped of its few adornments—shutters and entrance archway—simple features, but ones that gave the church its distinctiveness.

Five

ENSURING PROSPERITY

By the turn of the century, Norfolk's African-American population had made significant strides toward economic survival. This was accomplished certainly not by being integrated into the mainstream of Norfolk's workforce, but by seizing each employment opportunity no matter how small or menial. An examination of the City Directory of the first decade reveals the areas where African Americans were heavily concentrated. They were proprietors of eating houses, tailoring shops, barber shops, shoe repair shops, laborers of all types, household servants, waiters, and laundresses. A few who had had the advantages of a complete education were letter carriers. This occupation actually was regarded as quite prestigious within the African-American community since it implied an advanced level of literacy and knowingness. Also, it was guaranteed steady employment with government benefits. Often letter carriers' families were at the center of the social pecking order.

For the African-American community in Norfolk, the time between 1900 and 1939 was exciting and promising. Booker T. Washington's philosophy of economic enfranchisement through preparedness, training, self-help, and separation served as the model for Norfolk's aspiring business community. These years could quite appropriately be called the period of the American Dream. The expectation was that each and every African American could reach her or his full potential. This time was also, it must not ever be forgotten, a time of the harsh restrictions of segregation, Jim Crow, and the men of the sheets. Nevertheless, excitement filled the air and much was accomplished towards the goal of establishing economic prosperity.

J. Homer Rose is pictured in front of his Atlantic Pressing Club, a cleaning and pressing business. Like many other African-American businesses, such as Charles Carter's Tailoring, Goldie Garrett's Millinery, and Alston's Rubber, Rose targeted Norfolk's European-American community for his customer base. The advantage of this strategy became evident as the Depression approached. African-American workers were the most vulnerable to losing their jobs. Because the large percentage of their customers were African American, many of the Church Street merchants either were just able to squeak by or went bankrupt as their customers' economic prospects diminished.

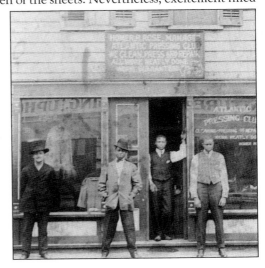

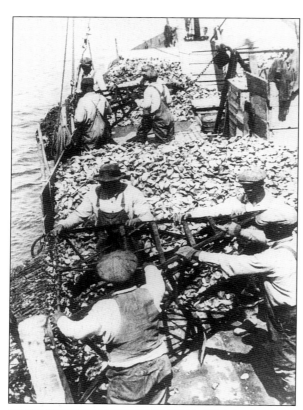

Oyster fishermen are unloading the oyster nets at the dock. There were many who excelled at this work and formed businesses of their own. Most notably was M.J. McPherson, who during his prime, cornered the market on the Lynnhaven oyster and crab market.

Cotton workers at the cotton warehouses unload cotton. Note the worker in the center who seems to have a bail of cotton on his scale for weighing. Norfolk was the major port of exportation for cotton grown in Virginia and the Carolinas.

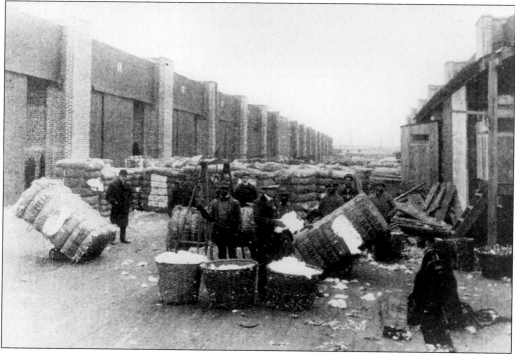

Another occupation available during this period was delivery person. Here James Jordan is posing beside his horse and delivery carriage. While this kind of work was often tedious, the hours long, and the pay meager, it provided those who could do it with steady employment for their families. There were no benefits, such as health insurance or dental plans, as we know them today.

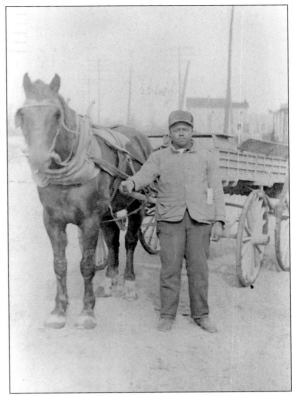

Dock work was plentiful and readily available to African Americans during the 1800s as well as at the turn of the century. At one time the great majority of haulers of materials from the docks to the factories and warehouses were African Americans. Here a crew of rope workers are pictured on the rope walk.

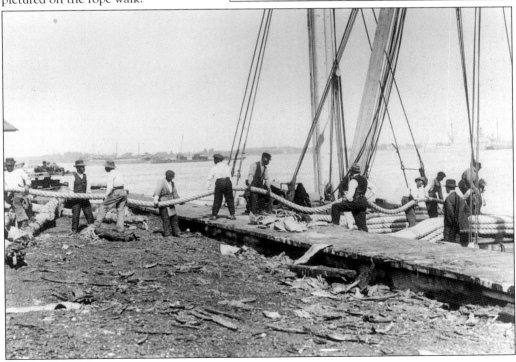

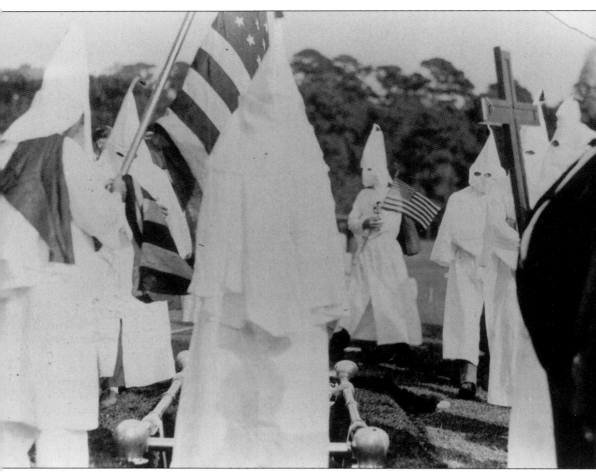

Above: This photo was found among those in the Isabelle and Carroll Walker Collection at the Kirn Branch of the Norfolk Public Library, Sargent Memorial Room. The caption written on the back says, "Burial of Martin L. Hundley at Forest lawn. Mr. Cox is on the right." The significance of the deceased and the man at the right is not known. What the photograph does suggest is that this funeral is for a person who was important in the Klan movement in Norfolk and that he was a well-known member of the Norfolk European-American community. It also frames the context of the time period in which African Americans were ensuring their prosperity.

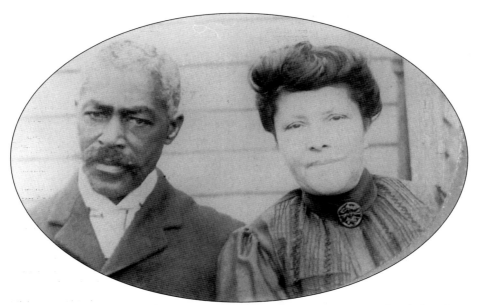

Frank Guy, shown with his wife, Annie, was a waiter by occupation. He decided early on that he wanted to have a life of more than subsistence. And so while being "Stephen Flecther like" obsequious, he was saving his tips to follow his dream of investing in real estate. By the time of his death he had amassed a number of significant real estate holdings in Norfolk.

Below is a copy of a lease agreement between Frank Guy and his tenant, Frank Fival of Fival Furniture Company, a popular furniture business in Norfolk. One of the paradoxes of race relations in the south was that while most European Americans were committed to separate but equal, and subjugated interaction where business was concerned, all money was equal. Therefore, renting from an African American was okay as long as the price was right.

THIS LEASE, made in duplicate, this 29th day of January in the year 1907, between Frank Guy of the City of Norfolk, in the State of Virginia, party of the first part and hereinafter called the "lessor", and of the same City and State, party of the second part and hereinafter called the "lessee".

WITNESSETH: That for and in consideration of of the rents, covenants and conditions hereinafter set out the said lessor doth hereby demise, lease and let unto the said lessee, for a period of one year, beginning February 15th, 1907 and ending February 14th, 1908, ALL THAT CERTAIN STORE-ROOM WITH DWELLING, known, numbered and designated at the present time as Kent Street in the City of Norfolk, Virginia, situated on the North East corner of Kent and Salter Streets in said City of Norfolk, Virginia, at an annual rental of THREE HUNDRED DOLLARS ($300.00) per annum, payable in equal monthly installments of Twenty-five Dollars ($25.00) on the first of each and every month. *Nathan Fival*

The said lessee covenants to pay the rent promptly when due, to keep the premises in good repair, and to surrender them at the expiration of the term herein demised, in as good order as the same now are or may be put into, reasonable wear and tear excepted.

In the event the said lessee shall be in default of any monthly installment of rent for a period of five days, or for the breach of any covenant, then the said lessor reserves the right and the said lessee agrees that the said lessor shall have the right to re-enter the premises, terminate this lease and take possession of the aforesaid premises. If the said lessee desires to rent the premises for another year upon such terms as may be agreed upon by the said lessor, he must notify the said lessor of his intention no later than three months prior to the expiration of this lease, and if the said lessor shall not desire to rent the said premises for another year, he must notify the said lessee no later than three months before the expiration of this lease.

IN TESTIMONY WHEREOF: witness the following signatures and seals this 29th day of January, in the year 1907.

_____ (Seal)
Frank Guy

_____ (Seal)
Nathan Fival

69

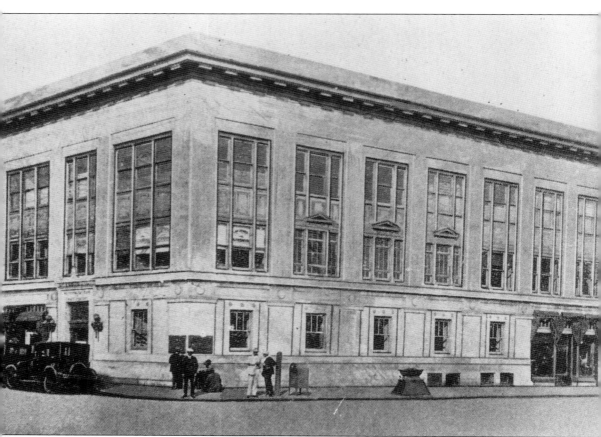

The Metropolitan Bank and Trust Company Building housed the premier African American Bank. There are several versions of its origin, one source, *Norfolk: First Four Centuries*, attributes its beginning to E.C. Brown's conversion of his Brown Savings and Banking Company into the Metropolitan Bank and Trust Company. It was said to have had a stock capitalization of two million in 1919. In addition to this bank there were other savings institutions and insurance companies. Three of the most outstanding were the Norfolk Home Building and Loan, the Community Building and Loan, and the Berkley Citizens Mutual Building and Loan Association.

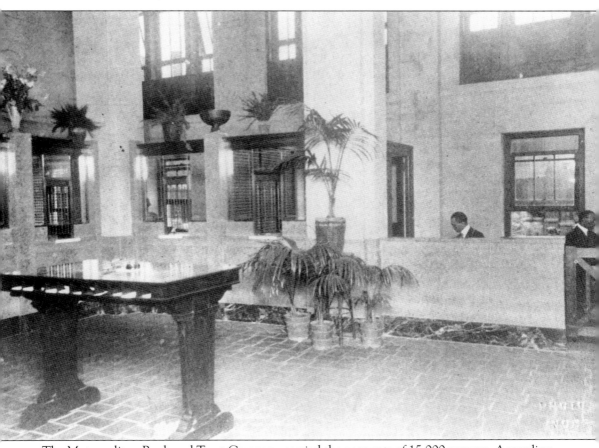

The Metropolitan Bank and Trust Company carried the accounts of 15,000 persons. According to a 1930 article in the *Norfolk Journal and Guide*, the bank had a paid up capital of $110,000, deposits of $568,402.80, and combined assets of $713,084.17. This is an interior view of the lobby.

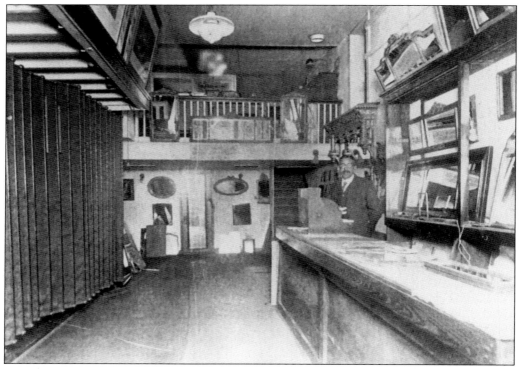

Henry Omohundro is inside the main showroom of his Norfolk Mirror Factory. All aspects of glass manufacturing were produced here—resilvering mirrors, making plate glass for automobiles, residences, and stores, and stained-glass windows for churches.

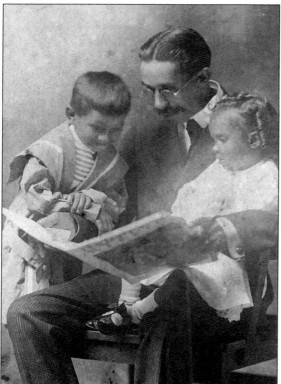

Henry Omohundro enjoys reading a story to his children.

The *Norfolk Journal and Guide* was one of the major weeklies for African-American citizens in the Tidewater and North Carolina area. It began as the *Lodge Journal and Guide*, the newspaper of the Supreme Lodge Knights of Gideons. Plummer Bernard Young was hired to become the plant manager in 1907. His tenure as plant manager was so successful that when the Gideons decided to liquidate the printing and publishing business, Young purchased the *Guide*. As the new owner, he expanded its mission and its circulation. The paper thrived. By 1919 it had a circulation of over 4,000 people. It employed up to 28 people full time and over 100 people part time. The picture above is of the printing annex that was next door to the main office building.

Homer I. Rose, who worked briefly on the circulation sales staff, is greeting Ellis Corbat, the *Norfolk Journal and Guide* circulation manager.

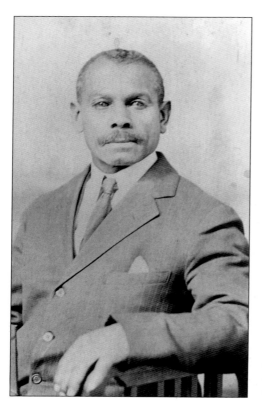

African-American entrepreneurship was not confined to downtown Norfolk or Church Street. Berkley, on the other side of the Elizabeth River, had an outstanding representative of African-American entrepreneurial spirit in the person of Samuel L. Clanton. Born in 1873, Clanton is the perfect example of the American success story, European or African American. His primary employment was as a railroad worker, which provided him with steady and continuous employment. To advance his economic opportunities, he invested in real estate, contracting, and a grocery store, Clanton's Grocery. He founded the Berkley Citizens Mutual Federal Building and Loan Association and was the director of the Southern Aid Insurance Company and the Metropolitan Bank and Trust Company. Clanton became so successful that he received a Dunn and Bradstreet rating. As with so many other businessmen whose clients were primarily African American, he was severely affected by the Depression and the Wall Street crash. Clanton's customers were the very first to be unemployed and to be unable to pay their debt to him.

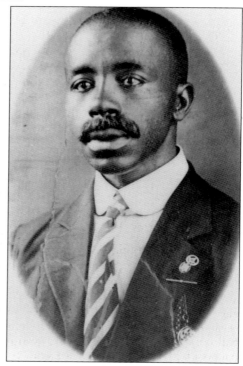

Samuel L. Clanton's son, Samuel Lincoln, who was born in 1906, trained to become a musician. For many years, he had a very successful career playing in Atlantic City, New Jersey.

Samuel Clanton's daughter, Hattie, and a friend of hers are wearing the fashion of the day, which is quite fetching. They were probably all dressed up to attend a party of some sort.

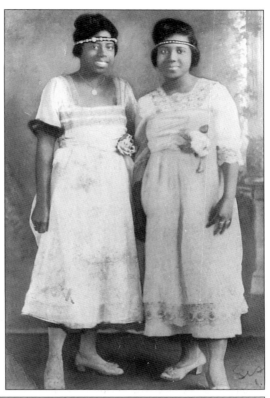

Norfolk, Va. 12-4-1935

Skinner, Gaynell C.your name has been entered on the Registration Book of the 32nd Precinct Annexed Territory Ward, located at #704 Campostella Road

When going to the Polls to cast your Ballot, you will assist the Judges by giving your name, stating you are No. 3 in Ss on the Temporary Roll. Colored.

Thomas J. Nottingham,
General Registrar.

Here is a copy of his daughter Gaynell's registration card for voting. This was very significant because voting was regarded as a very precious right, and those who could afford to pay the poll tax eagerly registered to vote, even though, as can be noted here, there was something temporary in nature about her registration.

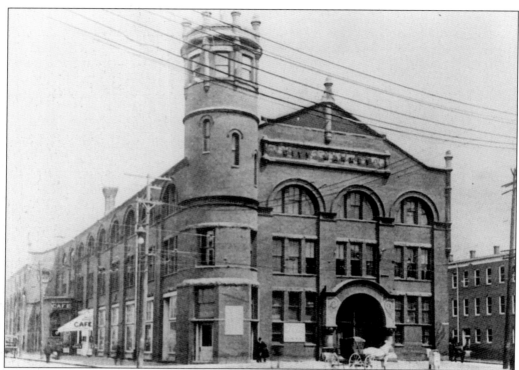

The Norfolk City Market served not only as the produce center for Norfolk, but also for all of the surrounding counties. Many enterprising African Americans were able to make a living selling goods and services in this market. Some did it fulltime, while others utilized it as an opportunity to provide additional income for their families.

Daniel H. Brown operated a very successful produce stall in the City Market. He was one of only a handful of African Americans who had stalls in the market.

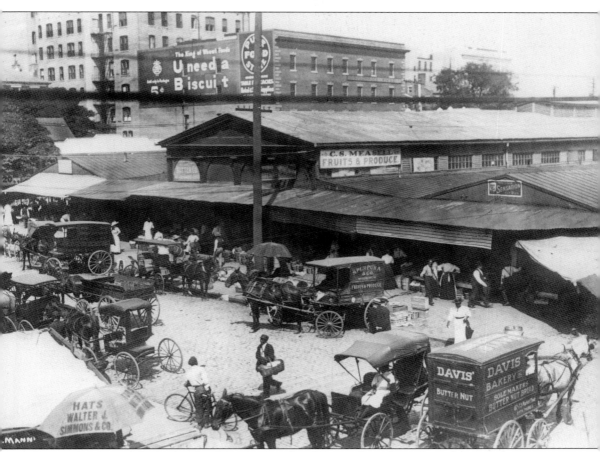

A street scene of the back side of the City Market depicts a busseling place where much activity took place, and all manner of products could be purchased.

Not all African-American entrepreneurs found their fortune in setting up business establishments. James Fulcher carved out a niche for himself by cornering the market on baskets for produce. Norfolk served as the marketing and shipping port for the surrounding local farms that produced potatoes, cantaloupes, spinach, corn, and other vegetable crops. This produced a steady need for baskets in which to store and transport the produce. Thus, by establishing himself as the local jobber for baskets, "Duke the Basketman," as he was popularly known, was able to provide a more than comfortable living for his family. (*Left*: Mr. Fulcher, *Right*: Mrs. Fulcher.)

This is a shot of the inside of the City Market where "Duke" had a stall.

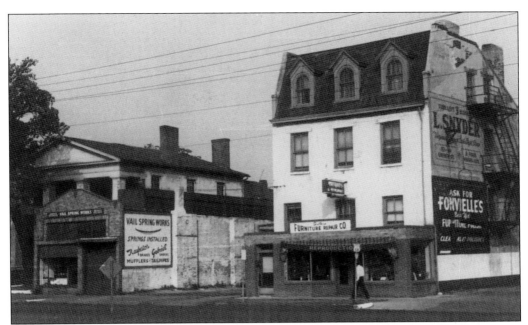

H.F. Fonvielle's Southern Furniture and Repair Company occupied a number of locations over the years. This company, which began its existence before the turn of the century, remained a viable and profitable business well into the 1940s, and some say even later than that.

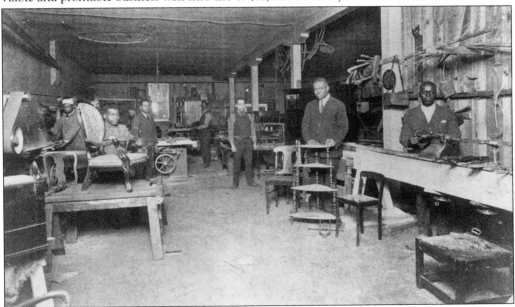

Furniture was made and repaired in Fonvielle's work room, pictured here. Fonvielle, who was born in the decade after the Civil War, probably learned his craft from his father, who was probably a skilled artisan before the Civil War. The Southern Furniture Company was so successful that it marketed its own furniture care products. Many older Norfolkians still remember Southern Furniture Companies' furniture polish and lament the fact that it is no longer available.

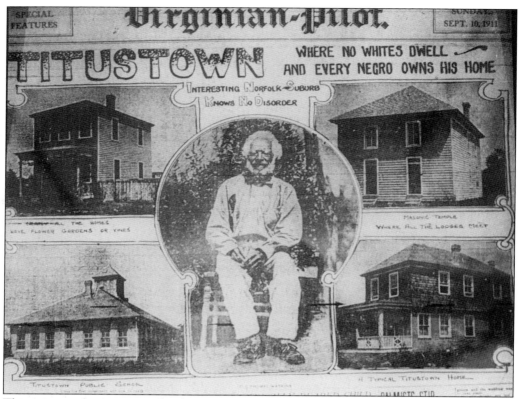

This is an advertisement for home ownership for African Americans. TitusTown was developed in 1902 when developer A.T. Stroud purchased the land and sold lots to African Americans with the requirement that the lots must be paid for before houses could be built. Why this requirement, one does not know. By the time this ad was run in the *Virginian Pilot*, there were approximately 600 people living in TitusTown with 90 homes, a church, a school, and several stores.

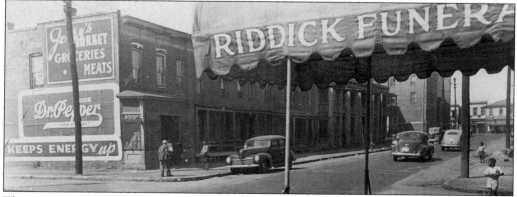

This street scene of downtown Norfolk captures the blight that had befallen the downtown area prior to the 1930s. Pictured is the awning of Riddick's Funeral Polar, which, during the 1920s and 1930s and for sometime later on, was the premier funeral polar for African Americans in Norfolk. Today, it is owned by a descendant of the original owner, who is also City Councilperson Paul Riddick.

Steady, secure employment choices for African Americans were limited, especially in the early decades of the 20th century; two of the most favored choices were pullman porter and letter carrier. Daniel D. Brown chose letter carrier. In this photo, he is shown in the mail-sorting room holding bundles of mail for his route. The article from which this photo was taken elaborates on how well he is thought of by the people on his route. What makes this significant beyond the usual is that his route was in Brambleton, a non-African-American community in Norfolk. In most cases, letter carriers were assigned to routes that corresponded with their race.

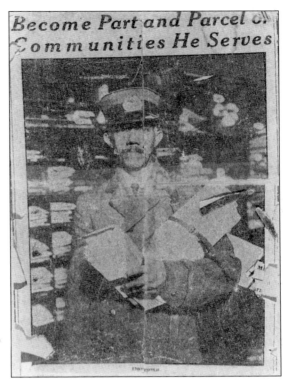

At the end of his tenure for the United States Postal Service, Mr. Brown was given a retirement celebration and rewarded with the customary "gold watch" for his long years of service.

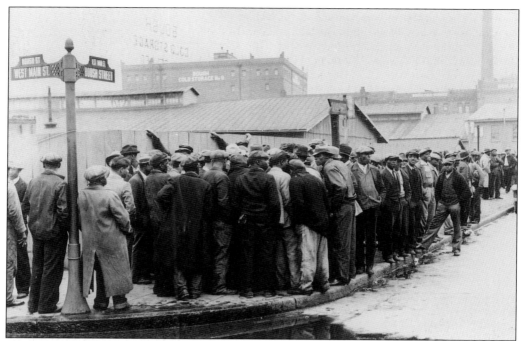

African-American longshoreman are shown on strike in 1934. African Americans had a long and continuous history of work on the Norfolk docks. Long before the ending of enslavement in 1865, Africans in Norfolk worked the docks. During the period prior to 1865, they formed the majority of draymen, ferry operators, and the like.

The WPA grant project to develop a botanical garden in Norfolk was controversial. When these women were hired, it was thought that they would only be doing the planting. Instead, they were given all of the heavy hauling and clearing that is usually reserved for males to do. This caused quite a stir and involved some form of arbitration to settle the matter.

This unidentified fellow stands proudly in his waiter uniform, towel across arm ready to assist his diners. In the faded background, there appears to be a beach. It was more than likely Virginia Beach. A number of African Americans were able to secure service jobs there. These jobs, while being somewhat at the lower end of the employment pecking order, proved to be steady and enabled many a parent to educate her/his children.

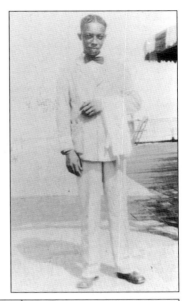

Foreman's Grocery was just one of the many "bodega"-like neighborhood stores that served the African-American neighborhoods. These little shops were usually mom-and-pop-type operations. One could purchase almost all of their grocery items there. Naturally the prices were inflated beyond what one could pay at the local supermarket. They, nevertheless, served a much larger function than a market. Here one was known, and often one could get credit for items purchased, or even momentary credit, as well. The relationship between the grocer and her/his customers was a valued one that often extended beyond the purchase of ordinary goods. In fact, the grocer and the customer were so interconnected that as the fortunes of one fell, so did the fortunes of the other.

This section of Norfolk, called Washington Heights, was developed by the real estate firm of Myers and Whitehill. The section is just east of the area platted as Lindenwood. This project was one of many in which houses were built expressly to be sold to African Americans. In most of the areas where African Americans lived, they moved into the neighborhoods after European-American residents began to move out. This was the case in the section just east of Church Street called Huntersville.

```
                                Norfolk, Va., Oct.,12th, 1911.

                        STATEMENT
        Jno.Tyler,                  Dr.,
                   To Lindenwood Corporation.

      To Lot #684,                            $ 265.00
       "  House,                              1,278.00
       "  Bldg. & Loan expense                  19.10
       "  3 years Int.                          33.12
      Feb.7th,
      To Bldg & Loan dues pd.                   19.20
       "  Int.                                   2.87

      Oct. 3nd, 1911.
      To Appraisers' fee new loan,               3.00
       "  Atty's fees,                           7.50
       "  Recording D.of T.                      3.00
       "  Bldg & Loan entrance fee, dues and book. 2.45
      Oct. 9th, 1911.
      To  Bldg. & Loan Dues,                     1.20
                                            $1,634.44

      CR.

      By credits pd. in         $ 178.00
       "  error of Jackson,         5.00
       "  First B. & L.         1,200.00
       "  2nd B. & L.             300.00
                               1,683.00
            Balance due Jno.TYler               48.56
                                            1,683.00

      Amt. due Jno.Tyler     $46.56
      Com. on lots,           10.00
                             $58.56
```

As noted above, Lindenwood was the section just east of Washingtion Heights. It was platted in 1884, and although a few European Americans lived scattered throughout, by 1910 it became the place for African Americans to build there own houses. This is a statement belonging to John Tyler from the Lindenwood Corporation, delineating the expenses for the house and lot he is purchasing. This document gives us some insight into the costs of home ownership for African Americans.

A street scene of the northern end of Church Street is pictured here. Church Street was the primary shopping and entertainment street for African Americans. Many shops were owned by African Americans, even though, historically, Church Street was the business street that provided opportunity for many of the newly arrived European immigrants.

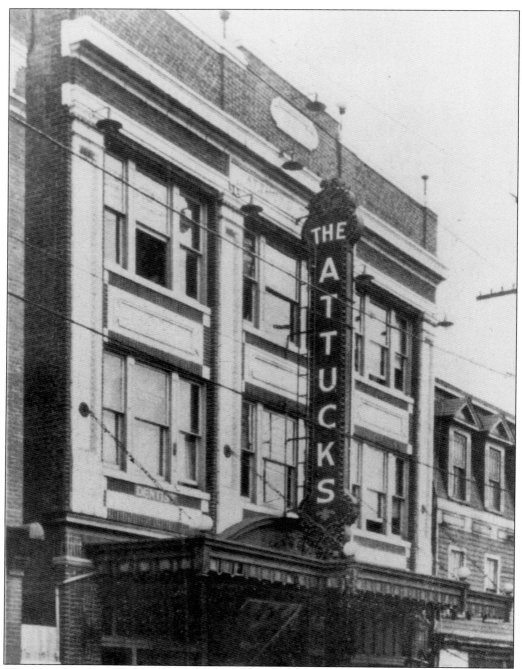

The Attucks Theater was designed in 1919 by the African-American architect Harvey N. Johnson. The building retains its original fire curtain, on which is painted the scene depicting Crispus Attucks's death in the American Revolution. The building has been designated a landmark by the Virginia Landmarks Registry and is one of the few examples of a structure not only designed by an African-American architect but also built and financed by the African-American community.

Six

PUBLIC EDUCATION

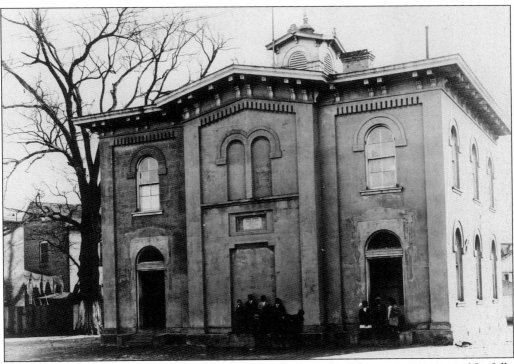

Access to education has always been a hotly contested area for African Americans in Norfolk. During the early years of the 1700s, the only education available to African Americans was provided by a 1701 Virginia statute requiring any person employing an apprentice to educate them in the three R's. Many semi-skilled and skilled artisans were able to obtain the rudimentary elements of reading and writing before this statute was repealed in 1805. Protestant Sunday schools were also another source of literacy for African Americans. Protestants were obligated by their theology to assure that their converts were literate so as to be able to read the Bible. During the period when Norfolk was occupied by the Union forces, all four of the European-American elementary schools were utilized for educating African Americans, leaving European-American children without schooling for two to three years between 1863 and 1865.

The J.H. Smythe School (above), one of the four schools used during the Civil War for the educating of African-American children, was built in 1858.

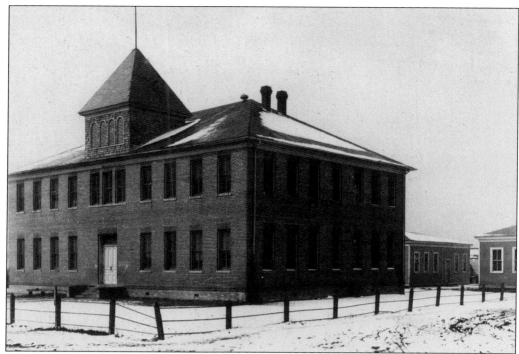

Bolton Street School was built in 1906. It was the elementary school to which the large majority of children who lived in Barboursville attended. Barboursville was the area on the other side of Cottage Toll Road, now Tidewater Drive. This area was a part of Norfolk County until the 1911 annexation. After 1922, Bolton Street School was renamed John T. West School. It was known for its rigorous curriculum and its high school department, where high school subjects were being offered: four years of English, history, science, Latin, and domestic arts and three and a half years of mathematics.

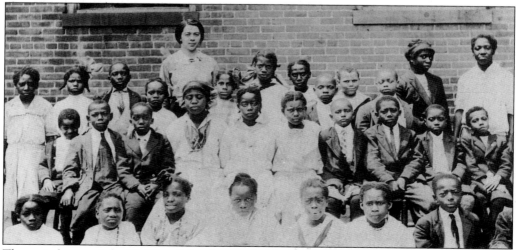

These students at John T. West School are probably fourth or fifth graders.

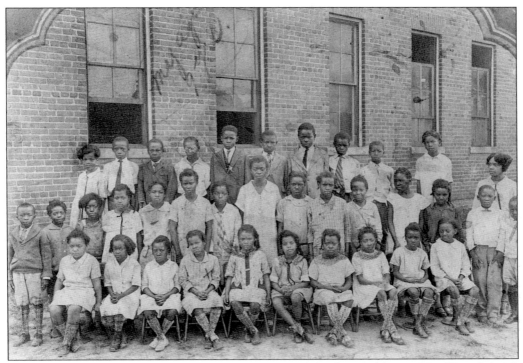

The number of girls outnumbers the boys in this 1927 third grade class at J.T. West School. This was because in some families the boys had to go to work to help provide subsistence for the family.

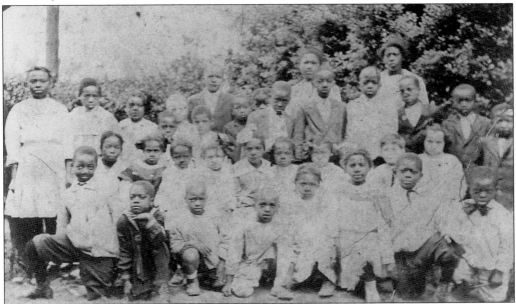

The ratio of boys to girls in this photograph of another class at John T. West is more even. Judging from the clothing styles, these children appear to be from an earlier period than the previous ones.

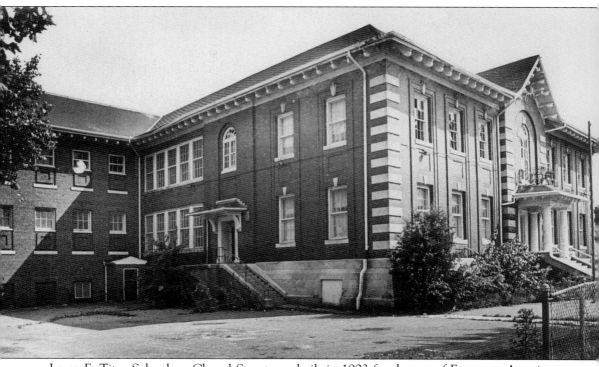

Laura E. Titus School on Chapel Street was built in 1903 for the use of European-American students. By 1935, the school was redesignated for the use of African-American students, and Mrs. Mildred D. Peters was appointed its first principal. Laura E. Titus, for whom it was named, was a Hampton Institute graduate (1876) and a very active member of the Norfolk community. She was the president of the Hunton Branch YMCA Ladies Auxiliary; later, she became the first president of the Phyllis Wheatly YWCA.

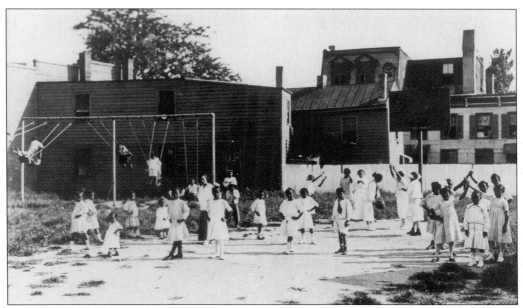

Children are on the playground of the Queen Street School. This school was located within the borough of Norfolk, and it was one of the original four schools built for the use of European-American children. However, during the war, it was used exclusively for the education of African-American children.

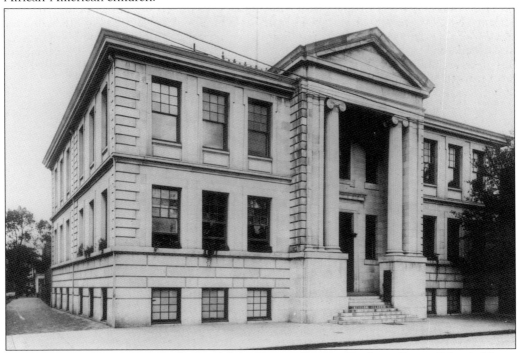

The reference notation on the back of this photograph says Charlotte Street School. If it is correct, then this would be another of the original four schools built in 1858. It then, too, would have been used for educating African-American children from 1863 to 1865.

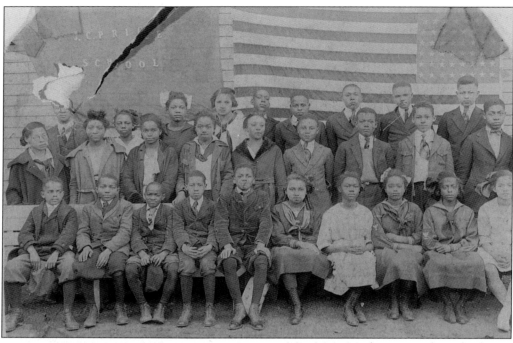

The Awakening of An American

Much am I now aware that I love this land;
Much am I now aware that I owe this land,
And how I wish to crush it to my breast—

You see, I have never held it close enough.

Yet, long have I known the pleasure of it;
The exhilarating joy of its nearness;
The pleasure to breathe its untainted air;
To stand atop some mountain and behold
Vast panoramic miles of unblemished freedom.

But I have not loved well or yielded
My fullest measure of devotion.
There were times when grumbling consumed me,
Some petty ire distorted my humble affection,
I censored it, but gathered its manifold goodness
And cursed its injustices—forgetting its justices.

But listen America!

Never before have I felt a kindred part of
Nathan Hale!
Never before have I encouraged within me,
The full meaning of Valley Forge, Saratoga,
Appomattox, Santiago, the Argonne;
Never before have I, sitting in my room,
Arisen and stood attentive to some radio
Rendition of the Star Spangled Banner!

. . . .

Busy noisy factories . . . twenty-four
hour shifts . . . rubber ration . . . "Keep
'em Flying" . . . bonds . . . stamps, to
me—a great American Symphony.

Strikes . . . isolationists . . . "bottle-
necks" . . . , unpreparedness . . . confu-
sion, once discordant notes of the
symphony, are no more.

A great harmony blends now to the
baton of a great maestro.

. . . .

But thanks to Pearl Harbor
I now know the meaning of it all;
The feeling that the greatest effort is not enough;
The swelling of the heart with pride;
The birth of reason, coolness, common sense;
The thrill of Khaki and Blue . . . Colin Kelly . . .
Wagner . . . Wake Island . . . !

Strange how one needs the tempest to
awaken to the beauty of a rose, or the
wolf at hand to know the nearness of
the Shepherd.

Co. 1375, Cape Henry, Va.
Winston M. Tyler, EA.

Miss M.A. Mosley's seventh grade class at J.C. Price School is shown here. For a long time, female teachers in Norfolk were not allowed to marry and, as a result, were always addressed as Miss. So strong was this custom that even to this day, many elementary students address their female teachers as Miss, a legacy from the past. These children are well dressed and poised. No doubt they were being educated with the expectation that they would train for professions. Notice the rather large American flag draped on the side-wall of the school building. It looks like they were also being trained for patriotism as well.

One wonders if Winston M. Tyler's seeds of devotion and love of country were planted in the fertile soil contained in the lessons he learned at J.C. Price School during his years there? Winston M. Tyler is pictured above, front row left.

When the City of Norfolk granted the first public high school for African-American children, the site of the former Norfolk Mission College was purchased and renamed Booker T. Washington High School. From 1916 to 1922, all African-American students attending high school in the city of Norfolk, Norfolk County, and the surrounding areas went to Booker T. Washington High School in the former Norfolk Mission College Building.

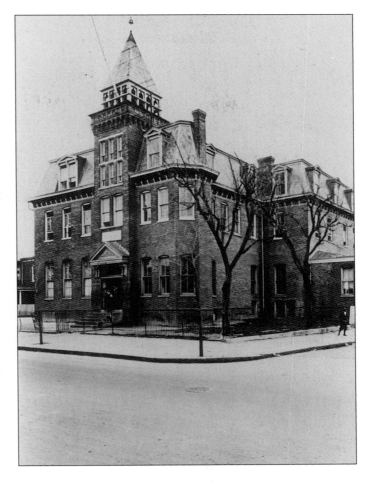

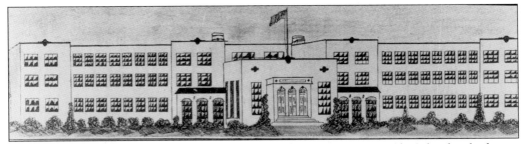

This is an architect's sketch of the new Booker T. Washington High School, which was completed in 1922.

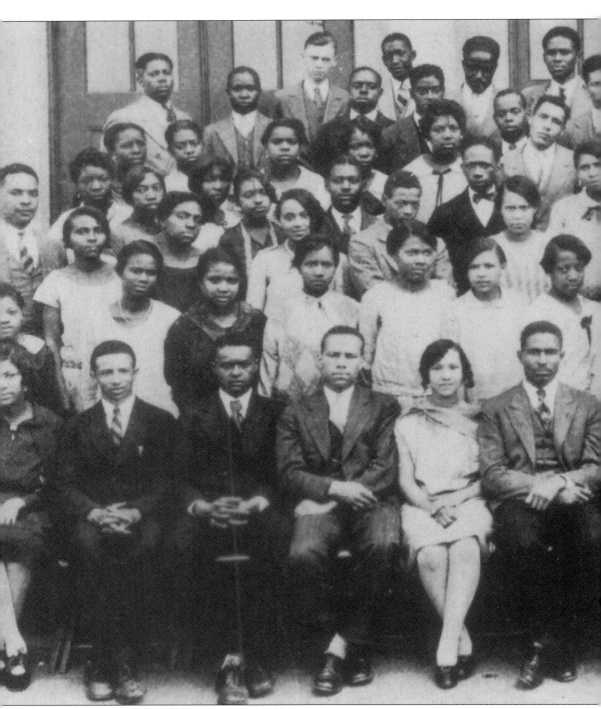

By the time of this photograph of the 1928 graduating class, the number of males slightly exceeds the number of females. It was probably no longer necessary for families to sacrifice their male children to the world of child labor. In the late teens and 1920s, prosperity was being experienced by a significant number of African-American families to make it possible for all of

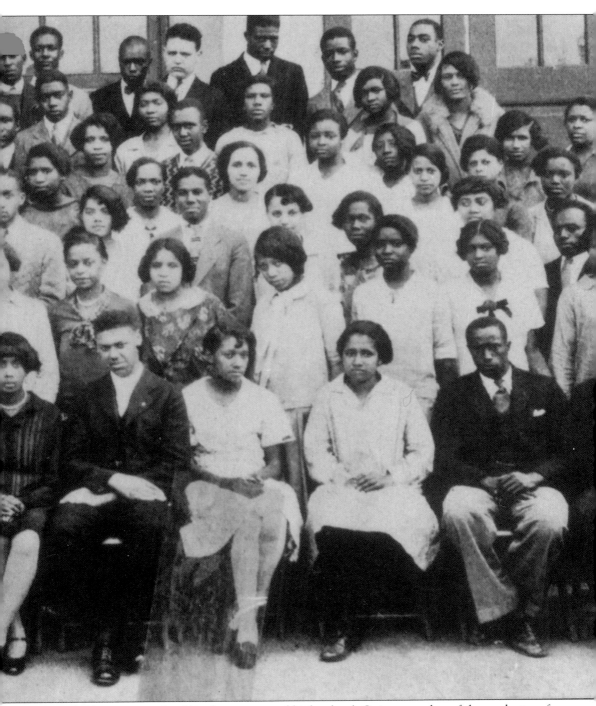

their children to attend public elementary and high school. Quite a number of the graduates of this particular class of 1928 went on to make a distinguishing mark in the world. They were sort of like the 1960s generation of their time.

Students gather at the left front side entrance to the 1922 Booker T. Washington High School building.

Students are discharging their civic duty by handing out leaflets on election day at Booker T. Perhaps because of the long and hard fought battle to eliminate the poll tax and make voting available to everyone in the state of Virginia, most African Americans take voting quite seriously. Even to this day, the African-American precincts in the city and in the state have a heavy voter turnout.

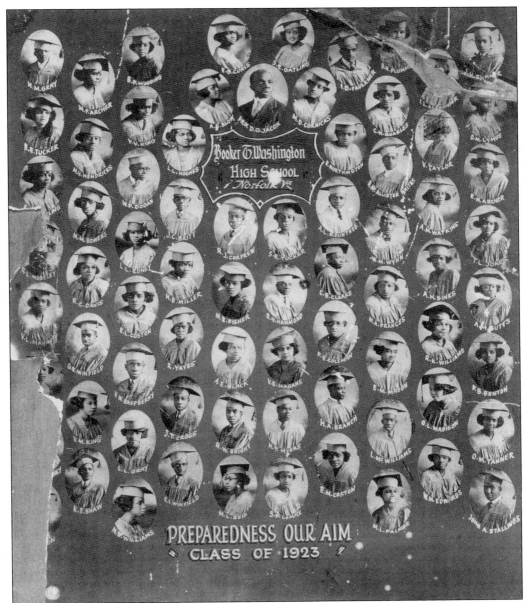

The 1923 graduating class of Booker T. Washington High School has adopted Booker T's philosophy of preparedness and made it its motto.

Originally when the city opened the first public library for African Americans in 1921, it was housed in the Booker T. Washington High School building. This photograph is of the new library, the Blyden Branch Library's second site. It is not new as in a new building, but new as in newly appropriated space.

The people in this photograph of the inside of the Blyden Library are all wearing their coats probably because the building was unheated. Victories during segregation were sometimes bitter sweet.

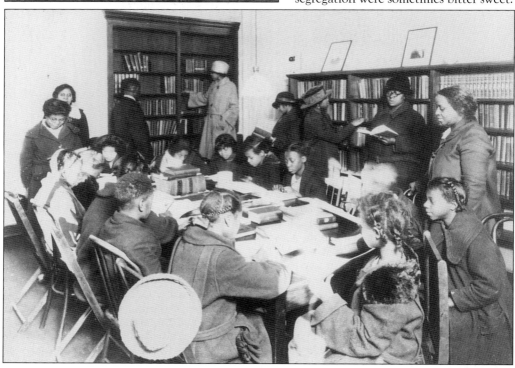

Seven

FAMILIES

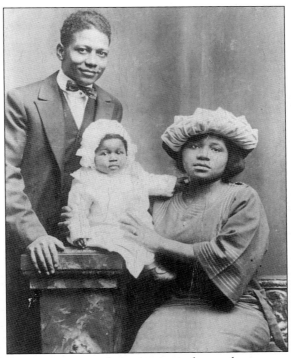

As a result of many factors—segregation being a principal contributing one—African-American family life was very closely knit. Each member of the family unit relied upon his/her family members. The major family pattern was seldom nuclear, but extended both biologically and fictively. The families presented here are a small sample of the many that exist. The community was thought of as one's extended family. Most individuals' construction of identity followed the West African Akan peoples' notion of "I am because we are; we are therefore, I am." This idea predisposed one to regard neighbors as members of one's own extended family circle and to both identify and connect one's fate to the success of the larger community.

This is an official family portrait of baby Evelyn with her parents Ethel H. and Charles B. Williamson. Mr. Williamson, who had a very strong sense of civic responsibility, served a tenure as the president of the local chapter of the NAACP. His daughter remembers him always engaged in some sort of debate around issues of the day, especially those that were germane to the African-American community. His passion for social justice fueled her desire to live a life of accountability to herself, her family, and her community.

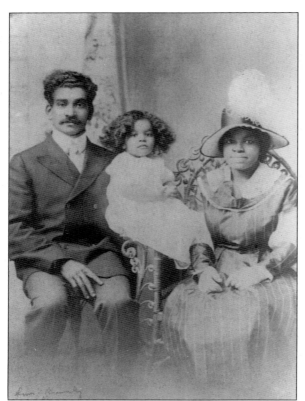

The Van-Arkadie family was interesting. Mr. Frederick Van-Arkadie immigrated to Norfolk from Sri Lanka as a very young man. After meeting young Lena and courting her for a while, they eloped. The 1917 photograph here is of their first-born daughter, Lillian. Later on, they were to have another daughter, Lena. Both Mr. and Mrs. Van-Arkadie were active members of the African-American community, as were their daughters, Lena and Lillian.

Pictured are the two Van-Arkadie girls, Lena nine months, on the left, and Lillian age four, on the right. Lena grew up to become a high school English teacher and Lillian a librarian.

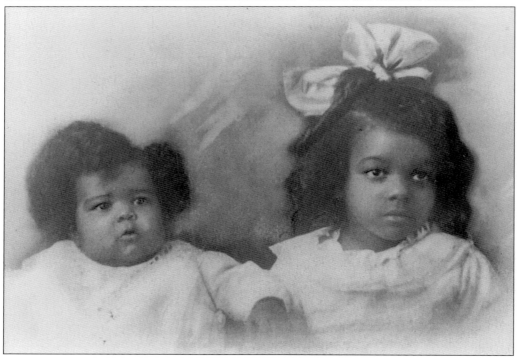

Mr. Van-Arkadie's sister, Lilian Van-Arkadie Rajah, is pictured in 1920, when she graduated from nursing school.

Lilian Van Arkadie is shown here all grown up.

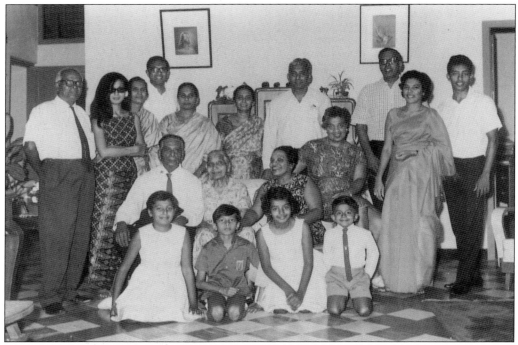

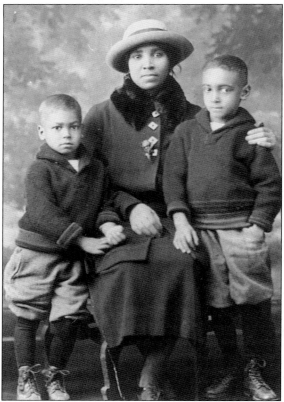

In 1968, after corresponding for many years, the Van Arkadie sisters traveled to Singapore where the Arkadie clan was living. It was the sisters' first seeing of all of their Van Arkadie relatives in person. In this photograph Lena and Lilian are sitting next to their Aunt Lilian, their father's sister.

Lena Van Arkadie grew up to marry William Dabney, who is shown here as a young boy (on the right) with his mother Henrietta and his brother Bernard in this 1925 photo.

This photograph shows aunt and niece posing for the camera. The bond between niece and aunt is often very very strong. Aunts are often more than Mother's or Father's sister, they are more like a cross between a big sister and a parent.

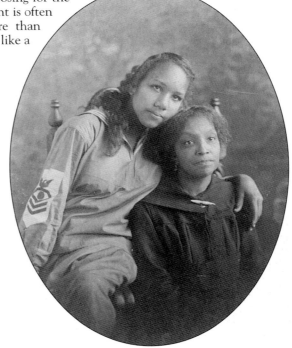

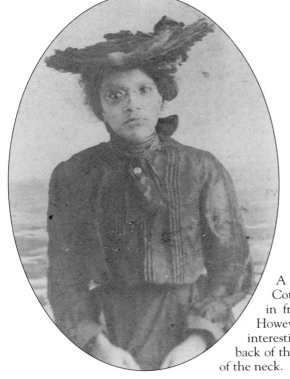

A more formal photograph of Cora Guy Cotton, she seems to be wearing a scarf tied in front and held together with a stick pin. However, note the bow at the back. This is an interesting feature. Bows were often worn at the back of the waist, but less usual is a bow at the back of the neck.

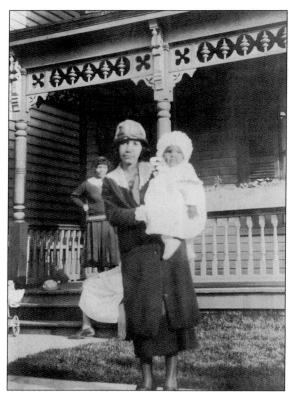

Marie Heywood is pictured here all grown up with a child of her own. Note the rather elaborate bonnet on her daughter, Bernadine. They are standing in front of their house on Kent Street where they lived for many years.

Bernadine White as a young girl of about 13 or 14 is posed in the yard of her house on Kent Street.

The McWilliams family is pictured here. Lucy Plummer married Green McWilliams in 1903 at the oldest Baptist church in Norfolk, First Baptist. They were married by the Reverend R.H. Bowling, D.D.

The couple posed separately in rather serious poses.

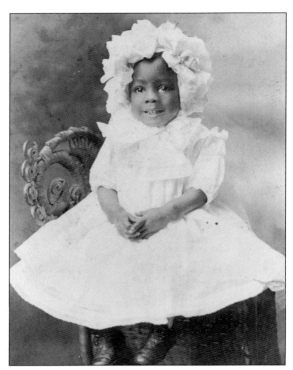

This charming-looking child posed in formal clothes is one of the McWilliams's sons, affectionately known as Mac. Notice the very elaborate bonnet and dress. Very young boys in a bonnet and dress were not uncommon at that time. It appears that he is about 11 or 12 months old.

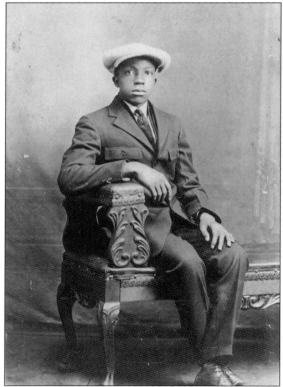

The older McWilliams son posed here in his suit and tie. The jacket has double pockets with buttons. Again we see the newsboy-style cap which has remained very popular even to this day.

This wedding announcement is of the wedding of Harriet Virginia Steptoe to Daniel D. Brown. When they were married on February 8, 1898, it was the custom to marry and then leave for a honeymoon immediately following the ceremony. The wedding reception, where the bride is presented to friends as the new Mrs. Brown, occurred five days after the ceremony. This custom seems a bit unusual to us today since the Bride and Bridegroom are presented to friends and family immediately after the ceremony and then they leave for a honeymoon. How interesting.

Mr. & Mrs. Green Steptoe
requests your presence at the
marriage of their daughter
Harriet Virginia
to
Mr. Daniel D. Brown,
Tuesday evening, February the eight,
eighteen hundred and ninety-eight,
at five thirty o'clock,
at
St. John's A. M. E. Church.

At Home after
February thirteenth,
252 Cumberland St.

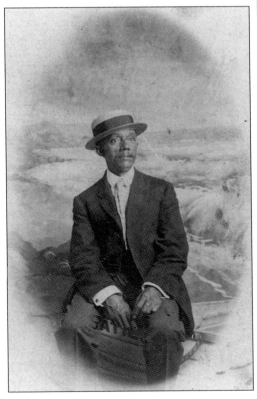

Mr. Daniel Brown posed here in his straw hat. Because he was one of the few to receive the benefits of an elementary school education, Mr. Brown became a letter carrier. Being a letter carrier carried a great deal of cachet; it provided much sought after steady employment, which permitted him to support his family in a style of his choice. And it solidified his family's position at the top of the social pecking order.

Mrs. Brown is pictured many years later in her garden. The Browns lived in downtown Norfolk on Cumberland Street. The five or six hundred block, it is recalled, was regarded as a prestigious place to live if one was African American.

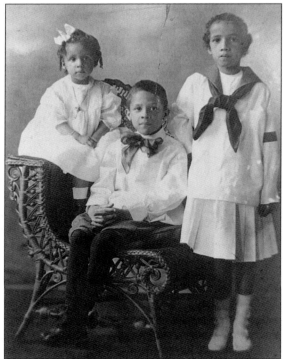

The three Brown children, Katherine, Allen, and Harriet, are pictured in their formal attire around 1910.

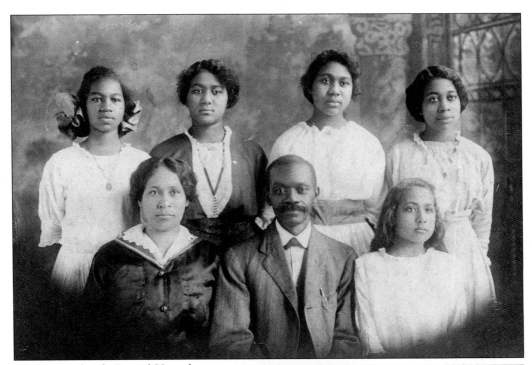

The Brown family Daniel H. and Susie K. Brown (seated) with their five daughters Bertha, Esther, Rae, Sarah, and Susie are pictured here. Susie would much later marry her classmate at Norfolk Mission College, William Miller. Mr. Brown operated a wholesale/retail produce stall in the City Market at which he was very successful. He was not only able to provide a comfortable living for his large family of five girls, but he was also able to send each one of his daughters to college.

Marian Miller Edmonds is pictured with her father William Miller.

The Tyler family is pictured in formal attire. They are Winston Sr. (standing), Mary Lou, Winston Jr., and Mary Lou Sr.

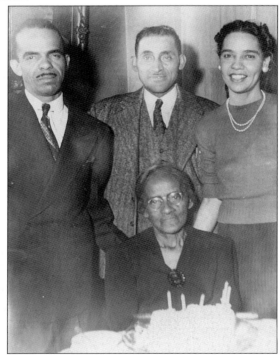

Mrs. Tyler's children, Winston, Walter, and Mary Lou, are at their mother's 80th birthday celebration.

This photo of John Homer Rose was taken not many months before his untimely death in 1920 at age 39.

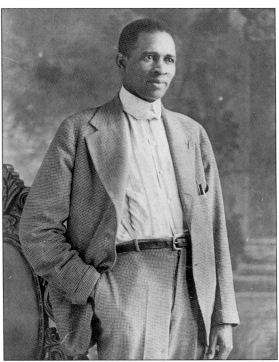

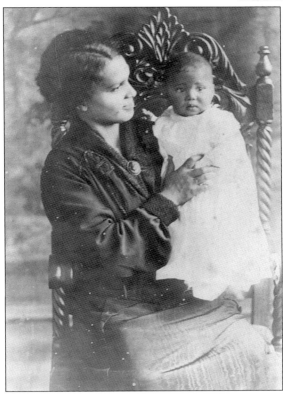

Ada Williams Rose is holding her last-born child Rebecca, who was only four months old when her father died suddenly after a brief illness.

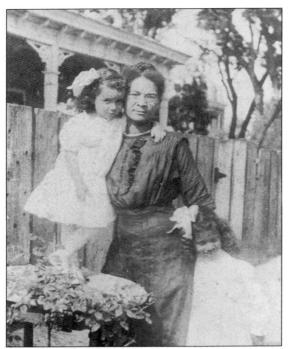

The woman and two small children are unnamed but their relationships are remembered. What is known about them is that they are posed in the backyard. The child standing on the table is the woman's child and the child at her side belongs to a neighbor.

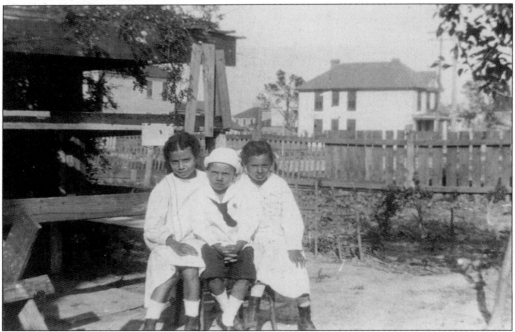

Three of the Rose children are posing in their backyard on Rugby Street in Norfolk. Look at that scowl on young Homer's face, one wonders whether his two older sisters Fannie and Mabel were terrorizing him? Or was this his version of trying to look "kool." This picture was taken around 1917 or 1918. By that time, Lindenwood had become a part of the city of Norfolk with the annexation of 1911.

Southall Bass, pictured as a young man, was the premier photographer of African-American life in Norfolk. He worked for the *Norfolk Journal and Guide* until his retirement. He photographed a great majority of the communities' official events, rites of passage, and struggles.

Mrs. Ruth Bass was widowed very early by her pharmacist husband, Dr. Southall Bass Sr. The couple had three children, Mary, Lucile, and Southall. They were both very active members of Saint John's AME Church.

When Southall Bass married Lena Baker of Williamsburg on June 17, 1939, their wedding was quite an occasion. Here they are posed after the ceremony as the new couple Mr. and Mrs. Southall Bass.

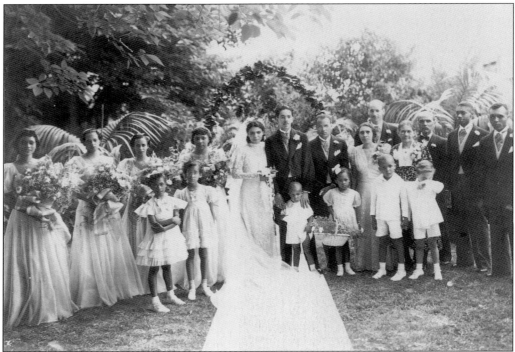

The entire wedding party is shown here in all of their splendor.

Eliza Coppage, a very studious girl who excelled at her studies in elocution, is most remembered for forming the Speech Choir. The speech choir would do recitations of popular poetry and prose using the call and response technique. To some extent they were reminiscent of an ancient Greek chorus.

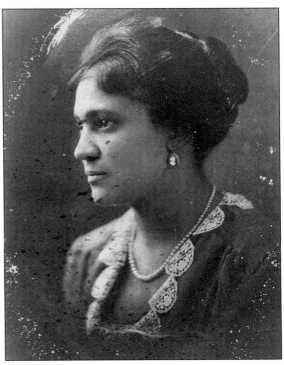

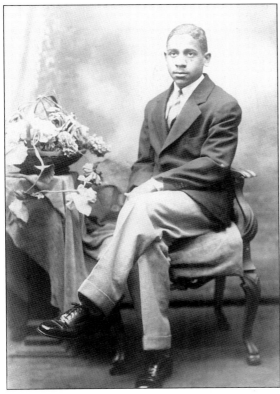

There is some dispute about this picture. It was originally thought to be the young Samuel F. Coppage, who grew up to become a leading activist in the African-American community. Others who knew him have said that this photograph is not the young Samuel F. Unfortunately, there was no way to settle the matter at press time. Samuel F. Coppage was on the forefront of the economic boom, the movement to provide quality health care, and very actively involved in several other movements for equality of opportunity for African Americans in Norfolk.

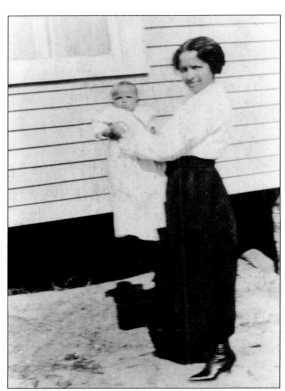

Lorena Coppage, the wife of James Coppage, is holding their only daughter, Lorena Jr.

James Coppage strikes a serious pose.

These couples are unidentified. They are pictured here in formal outerwear. In the first photograph they were both wearing their coats and hats. One wonders why. It does not seem to have been the custom during that time to take formal photographs in one's outerwear. This perhaps signifies something but just what it is is not known. Another interesting observation is that the wife appears to be wearing something that looks like spats over her shoes.

This second couple is also pictured with their outerwear. While the man is wearing a suit, it appears to be a heavy suit that can serve both as outer- and innerwear. His wife is wearing her winter coat with its fur trim. Notice the vale on her hat—an interesting combination.

The young Bessie Omohundro is posed for a photo to record a special occasion. There is no indication from the photograph just what the occasion is; however, she is wearing a corsage on her left shoulder.

When this picture was taken of Purnel Omohundro, he was probably just out of high school.

This picture of Mrs. Bessie Omhundro's aunt was taken before the century began, as we can see from her clothing style. She has a no nonsense stare which was characteristic of so many people of that period when life offered many opportunities as well as many obstacles.

The couple here is very young. They are related to Bessie Omhundro on both her paternal and maternal sides of the family. They would be called cross cousins, cousins without blood ties or cousins-in-law.

One wonders why this fellow chose to sit for a formal photo while wearing a hat. Did his hat represent something special to him? Or perhaps the entire outfit, suit and hat, forms an image that he is trying to convey.

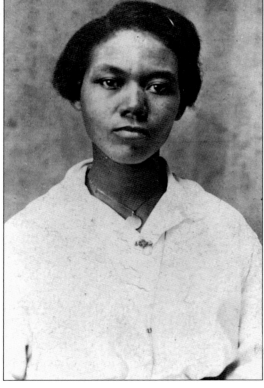

This seemingly unadorned young woman is wearing three pieces of jewelry in the most interesting fashion. She has a locket on a chain around her neck, then a small broach connecting her collar, and then a much longer chain with a small clasp that hangs down to her mid chest. The wearing of multiple chains which is so popular today seems to have also been popular many decades ago.

Eight

LEISURE AND
MEDICAL CARE

In the early teens on into the late 1920s and early '30s, Lemule Bright operated a private beach for the African-American community. It was located out towards Ocean View in the Willoughby Split area. Little Bay was very popular with all segments of the community. Social clubs, church and fraternal organizations, schools, and the like would organize picnics and outings to Little Bay. During the summer the large hall would be booked solid with parties, dances, weddings, and all kinds of social events. It was conveniently located and easily reached by trolley, bus, and automobile. After arriving at the designated stop, one could walk along a long path through a very pleasant and relaxing park to the beach or one could be picked up in a small row boat ferried by Mr. Bright's son.

A family—mother, father, grandmother, and child—are on their way through the park to the main quarters, which can be seen in the background.

This was probably a social club of some sort or even a church club enjoying an outing at Little Bay. Notice how well dressed all of the people are. This gathering, it would probably be safe to say, was not an occasion for swimming but probably more for a celebration. In the background are three of the structures that made up the Beach area. The rather large cottage includes a main house, which one could assume housed most of the guests and probably the dining hall, and on the right-hand side of the main house is what appears to be the social hall for dancing

and celebrations. From this shot it appears that the area from the beach to the water was quite a ways, so anyone wanting to wade in the water would have to go some distance to get to the shoreline. This is not really unusual since even on our modern beaches the distance between the water and the boardwalk is quite aways. However, it does seem a bit far for the likes of a private beach.

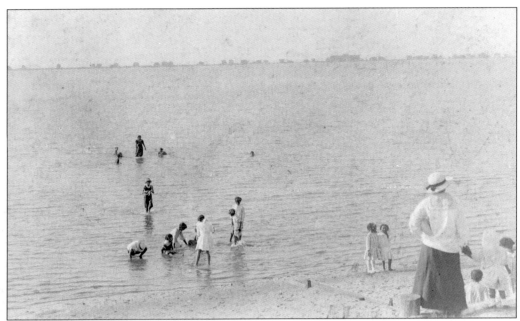

This scene reveals the customs of the day. Notice that the bathers are almost fully dressed, a far cry from the habits of today. Even the little children here are in rather full dress. Some are even still wearing their socks and shoes. One little girl who is walking towards the shore appears to be wearing some sort of bathing costume, but notice how unrevealing it is. Moreover, she has on a hat which suggests that she is not a swimmer.

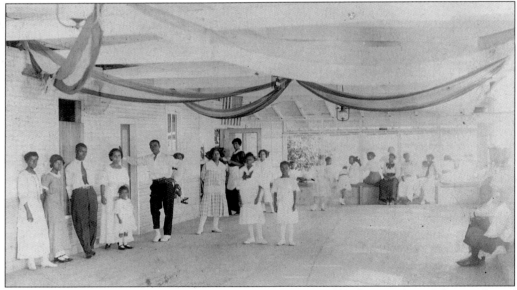

This was probably a Saturday afternoon party of sorts. It is still light outside and the number of guests is few; there were likely many more to come. Although the women are dressed up, they do not seem to be wearing jewelry of any sort. Could this have been a church group? The men are attired simply also, except for the fellow in the white boots with his pants leg pulled up, some sort of style, perhaps?

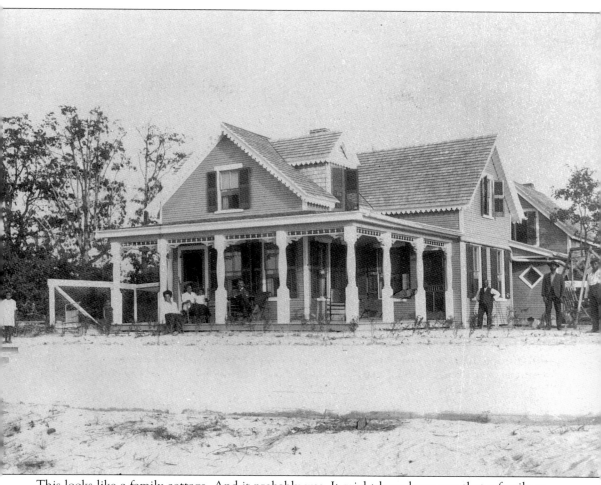

This looks like a family cottage. And it probably was. It might have been one that a family or group could rent so that they could enjoy some privacy. Notice the gingerbread trim and the structure directly behind it. It appears to be attached; it probably was since during these early years of the 1900s, most houses had bathrooms and kitchens located at the end of the house. They were attached structures, but not a part of the main structure as they are today. They were not rooms within the house, but rather houses of their own almost. The people in this photo appear to be members of a family and workers. Notice the difference in dress between the men. The man wearing the overalls was probably the gardener, the man wearing the hat and jacket probably did some of the handy work around the property, and the man wearing the shirt and vest was probably an administrator of the property. The four people sitting on the porch appear to be members of one family—father, mother, grandmother, and child. The little girl off to the left might also be a family member, or just a miscellaneous child belonging to one of the workers.

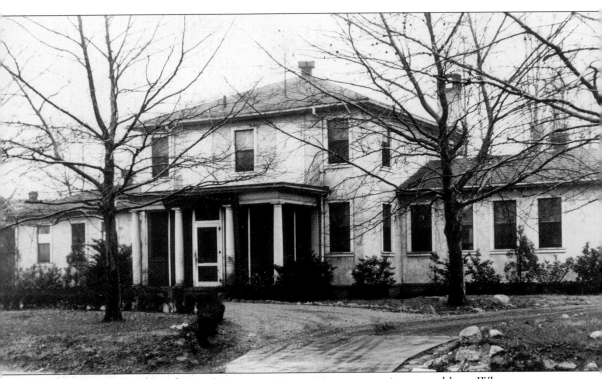

Health care for the African-American community was a persistent problem. When someone became ill, all that was available were a few beds in the basement of Saint Vincent's Hospital, where the facilities were extremely primitive. Among the exposed pipes, boiler, furnace, garbage bins, and all sorts of basement equipment were a few beds reserved for African-American care. Needless to say, the need for sanitary, safe, and sufficient medical care and facilities was acute.

The official history, as published by the Norfolk Community Hospital Association, is, ". . . The Tidewater Colored Hospital Association . . . was incorporated on April 16th, 1915 to secure, equip, and maintain a hospital, *Tidewater Colored Hospital*, in the City of Norfolk for the benefit of colored citizens and in which a training school for nurses could be made. The hospital was located at 1452 Forty-second Street until 1930 when Dr. Drake died and Dr. J.Q.A. Webb became its Surgeon-in-Chief. The hospital was renamed *Drake Memorial Hospital* at the encouragement of the Board of Trustees. In 1932 concerned civic organizations united and petitioned the City of Norfolk for larger facilities. On October 5th, 1932, Norfolk Community Hospital began operations in the former Henry A. Wise Hospital for Contagious Diseases, colloquially refereed to as 'The Pest House.' "

By 1938, Community Hospital had outgrown the facilities at 800 Rugby Street. That same year the City Manager was authorized by the Norfolk City Council to secure a Works Progress Administration grant to help finance and construct a 51-bed fireproof hospital building.

In addition, the Norfolk City Council turned the operation of City Beach over to Community Hospital, which provided a major source of revenue for the hospital. City Beach had been established in 1934 for the use of the colored citizens of Norfolk. In 1938 a separate corporation was set up to manage and operate the beach. The purpose was two-fold, to expand and develop the recreational opportunities available to African-American citizens, and to provide a mechanism for funding of the hospital by returning the profits made by the beach to the hospital for upkeep and development of hospital facilities. Another benefit of this plan was to increase the employment opportunities available to the African-American community.

Dr. Samuel F. Coppage was one of the original incorporators of the Tidewater Colored Hospital Association. Dr. Coppage was also a member of a group of prominent citizens who petitioned the Norfolk City Council on June 1, 1932, to have the Henry A. Wise Hospital for Contagious Diseases made available to the African-American community.

Dr. Grandy and the nurses of the Colored Maternity Ward and the Henry Street Branch of the Norfolk Health Department stand outside the Henry Street facility, which operated from 1925 to 1932.

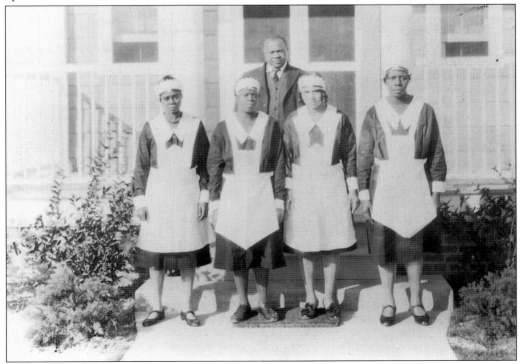

THE MEDICAL STAFF

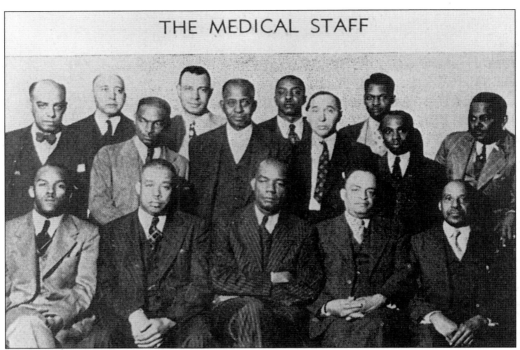

The 1938 medical staff of Norfolk Community Hospital, from left to right, are as follows: (seated) Dr. A.C. Fentress, Dr. J.Q.A. Webb, Dr. G. Hamilton Francis, Dr. F.R. Trigg, and Dr. J.L. Sapp; (standing) Dr. J.D. Jackson, Dr. J.A. Byers, Dr. C.R.S. Collins, Dr. J.T. Moone, Dr. W.P. Collette, Dr. F.W. James, Dr. W.M. Hoffler, Dr. J.H. Owens, and Dr. C. Eugene Sumner.

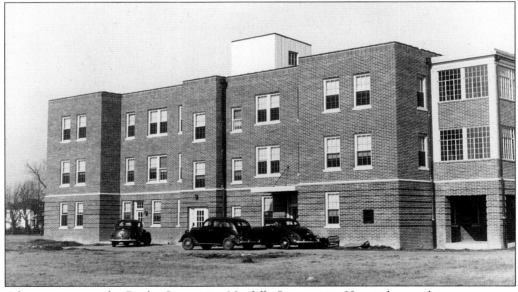

After six years at the Rugby Street site, Norfolk Community Hospital moved to a new more modern and spacious building on Corprew Avenue. This new building was designed by architect Benjamin F. Mitchell. It is a 65-bed facility with all new and modern equipment. The funds for the new structure were from a Workmans Progress Administration grant.